NT,
TER,
DIP, DRIP,
& COLOR

ART OF CUSTOM
SNEAKERS
HOW TO CREATE
ONE-OF-A-KIND KICKS

ROCKPORT

Quarto.com

First published in 2023 by Rockport Publishers, an imprint of The Quarto Group,
100 Cummings Center, Suite 265-D, Beverly, MA 01915, USA.
T (978) 282-9590 F (978) 283-2742

Rockport Publishers titles are also available at discount for retail, wholesale,
promotional, and bulk purchase. For details, contact the Special Sales Manager
by email at specialsales@quarto.com or by mail at The Quarto Group, Attn: Special
Sales Manager, 100 Cummings Center, Suite 265-D, Beverly, MA 01915, USA.

This book is for customization of sneakers you have purchased or otherwise
legitimately acquired, for your personal use only, and not for resale to others.

10 9 8 7 6 5 4 3 2 1

ISBN: 978-0-7603-8180-9

Digital edition published in 2023
eISBN: 978-0-7603-8181-6

Library of Congress Cataloging-in-Publication Data

Names: Crews, Xavier, author.
Title: The art of custom sneakers : paint, splatter, dip, drip, color, and
 create one-of-a-kind kicks / Xavier Crews.
Description: Beverly, MA, USA : Rockport Publishers, an imprint of The
 Quarto Group, 2023. | Includes index. | Summary: "With Art of Custom
 Sneakers, learn to make your own one-of-a-kind kicks from YouTube
 superstar Xavier Kickz"—Provided by publisher.
Identifiers: LCCN 2023011932 | ISBN 9780760381809 (trade paperback) | ISBN
 9780760381816 (digital edition)
Subjects: LCSH: Textile painting—Amateurs' manuals. | Sneakers—Design and
 construction—Amateurs' manuals. | Clothing and
 dress—Remaking—Amateurs' manuals.
Classification: LCC TT851 .C74 2023 | DDC 746.6--dc23/eng/20230317
LC record available at https://lccn.loc.gov/2023011932

Design: Cindy Samargia Laun
Illustration: Blake Showers (www.blakeshowers.art)

Printed in China

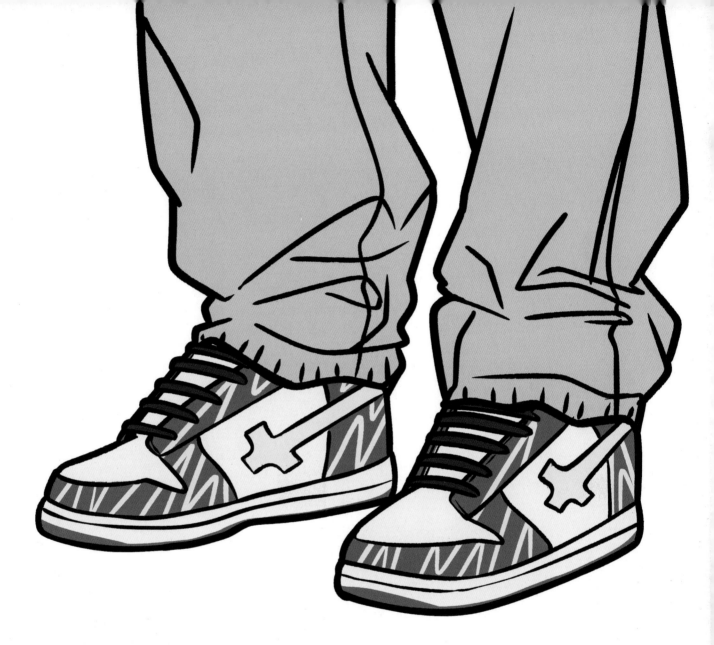

DEDICATION

I want to dedicate this book to all of my subscribers.
Their support, dedication, and love for me has truly
inspired me to create this book for them. I hope this
book inspires you all to be the creative person
I know lives in you.

contents

Introduction --- 7

SNEAKERS IN HISTORY 8
Definitive Moments in Sneaker Style

Q&A --- 10
 Xavier's Frequently Answered Questions -------- 10
Workspace, Materials, and Tools ------------------- 14
 Workspace -------------------------------- 14
 Materials --------------------------------- 15
Prep and Finishing Basics ----------------------- 19
 Laces ------------------------------------- 19
 Surface Cleaning --------------------------20
 Taping ----------------------------------- 22
 Finishing ---------------------------------- 23
Planning Your Design --------------------------- 24
 Designing --------------------------------- 24
 Practicing Your Brushwork and Pen Work------- 25

1 Customizing with Paint 26
Sprinkle Drip Kicks ----------------------------- 28
Cartoon Kicks ---------------------------------- 32
Tiger Stripes------------------------------------36
Dragon Kicks ----------------------------------40
Painted Plaid ---------------------------------- 44
Freestyle High-Tops ---------------------------50
Toothpick Painting------------------------------ 54

2 Paint Pen Color 60
Paint Pen Camo---------------------------------- 62
Fine-Line Quickie ------------------------------- 66
Paint Pen Doodling ----------------------------- 70
Paint Pen on Dark Color ------------------------- 74

SNEAKERS IN CULTURE AND COMMUNITY 78
Sneakers, Sports, and Getting That Look

3 Crazy Color 80
Shaving Cream Color ---------------------------- 82
Sharpie Tie-Dye ---------------------------------- 86
Cool Color Drip ----------------------------------90
Hydro-Dipped Marbelizing ---------------------- 94
Galactic Splatter --------------------------------- 98

4 Airbrush and Stencil 102
Airbrushing Basics ------------------------------ 104
Airbrushing Black Leather------------------------ 108
Mix It Up ---112
Handmade Stencil --------------------------------116
Hot Stuff --- 122
Color Waves------------------------------------- 126
Team Spirit --------------------------------------- 132

5 Paper, Cloth, Glitter, and Shine 138
Fabrication Transformation ---------------------- 140
Bedazzled Flash --------------------------------- 144
Brushed-on Glitter ------------------------------- 148
Cut-Paper Collage ------------------------------- 152

SNEAKERS IN POP CULTURE 156
A Timeline of Kicks in Music and Movies

About Xavier----------------------------------- 158
Acknowledgments----------------------------- 158
Index --- 159

Hey. I'm Xavier Kickz. Some of you already know me from my YouTube videos, talking about my favorite subject: customizing sneakers. Now I've got all my customizing tips and techniques right here in one beautiful book to make it easy for you to get started. Keep it open on your worktable. Flip through it while you're working to find out what you need to know—whenever you need to know it.

Since the 1980s, when the first commercially produced custom sneakers were created for basketball's biggest stars, the art of custom has taken off—worldwide. At first, artists painted their shoes in imitation of those unattainable commercial creations, but then hand-painted custom sneakers became the crazy, innovative art that it is today, and it just keeps getting more exciting. It's such a great way to show off your talents. The manufacturers now imitate the artists! Yeah.

Nothing's cooler than wearing a pair of custom kicks that are totally one-of-a-kind—especially if you're the artist who created them. They match your style, they tell everyone who you are, they let them know you're an original, and they look so good.

And that's what this book is all about. All of you beginner and intermediate sneakerheads out there who want to get started, I'm giving you everything you need to know about the different techniques for working on leather and canvas sneakers—prepping, painting, airbrushing, doodling, hydro dipping, toothpick painting—it's all here, step by step, with plenty of illustrations so you can see how it's done. Each chapter starts with the easiest and ends with the most challenging custom sneaker, so take your pick.

My favorite part of what I do is inspiring people who are just starting to create. Everyone needs an outlet for their creativity—even people who didn't know they were creative before. In this book, I've tried to make it easy and fun for you to copy and build on the designs I've come up with. I hope that when you see the step-by-step instructions, they'll give you the confidence and inspiration to do it yourself. I love seeing what everyone can do on their own.

So try out each technique and get the hang of it, because once you've got the basics down, you can go in any direction you want. Go crazy with your creativity. Tell the world who you are—feet first—because who wants to look like everybody else?

Have fun with it—

SNEAKERS
IN HISTORY

DEFINITIVE MOMENTS IN SNEAKER STYLE

Have you ever wondered about the who, what, where, and when of sneaker design? Your favorite footwear has been evolving for nearly 200 years—one small detail at a time. Sneakers began as a beach shoe, quickly became a sports shoe, and finally morphed into the fashion statement they are today (with a global market predicted to reach $120 billion by 2026). The look keeps changing, but certain elements have stayed the same—here are a few dope milestones in how sneaker style developed.

Rubber Soles and Canvas Tops

If you think of sneakers as rubber-soled shoes, their history began in 1832 when a man named Wait Webster in New York patented a process for attaching India-rubber soles to shoes. These were flimsy—a cheap canvas shoe for walking on the beach. But the process was hugely improved after 1839, when Charles Goodyear invented a way to vulcanize rubber—making it much stronger, more flexible, and less prone to drying out.

DYK?

Sneakers were originally made by tire manufacturers, not shoe companies. In the early 1900s, Goodyear, The U.S. Rubber Company, and Hood Rubber all made basketball shoes: P.F. Flyers, Keds, and Arrows.

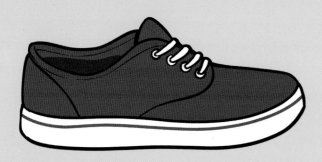

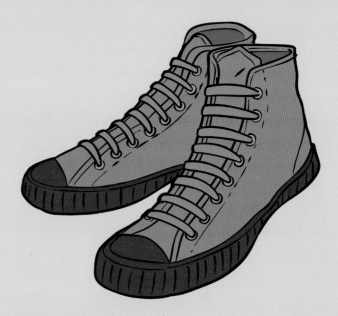

Those Distinctive Stripes

In 1876, the New Liverpool Rubber Company in England devised a sporty-looking technique for reinforcing the join between the upper part of a canvas shoe and the rubber sole—a thin band of rubber that wraps around the shoe. These were known as plimsolls because the rubber striping reminded people of the plimsoll lines painted on ships to indicate the weight of the cargo.

Customized Canvas and Versatile Soles

People immediately began customizing their plimsolls—painting them white in imitation of the expensive white kangaroo-skin shoes that posh players wore for croquet. In fact, their versatility launched plimsolls as the forerunner of the modern sports shoe, as different types of rubber sole patterns were developed for their use on grass and cinder tennis courts, for boating, and for track events and long jumping.

Who Are You Calling Sneaky?

In 1916, U.S. Rubber and Goodyear merged and produced a flat-soled canvas and rubber shoe similar, to the British plimsoll, that they called "sneakers"—the name schoolboys gave tennis shoes because you could sneak up on people when you wore them. In fact, thieves who wore cheap rubber shoes were known as sneak thieves.

At Ease in High-Tops

Because rubber was needed by the military during World War II, commercial sneaker production stopped and sneaker factories were converted for making military supplies. Leather shoes were rationed too, leading shoe companies to experiment with making shoes from synthetic materials. The government-issue sneakers made for American soldiers in World War II were the forerunners of today's high-tops.

Rubber Toe Caps

The British Military and plimsolls also contributed to the evolving style of sneakers during World War II, adding a rubber toe cap to sneakers issued to soldiers, and producing sneakers in different colors for the various military branches. Rubber toes would later be adopted for sport sneaker styles.

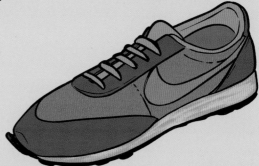

Waffle Soles

In 1971, Nike co-founder and former track coach Bill Bowerman wanted to rethink running shoes—to give them a sole without spikes that would still grip effectively on grass or a cinder track. At breakfast one morning he noticed the grid of the waffle iron and—We got it! Back in his lab, he poured urethane into a waffle iron to create a prototype. The Waffle Trainer debuted in 1974. It was the birth of the rubber-soled running shoe—there's a pair in the Smithsonian.

XAVIER'S FREQUENTLY ANSWERED QUESTIONS

Here are a few answers to questions I'm asked most often on social media. Maybe you've been wondering about these things too.

Q: **I'm not an artist. I've never painted before. Can I do this?**

A: Easy answer—Yes!

I get asked all the time what kind of art training I had, or if I was always doing artwork as a kid growing up. And the truth is, I never had any kind of art training—none—and I was not one of those kids who was drawing all the time. In fact, never.

I started customizing shoes out of the blue when I was about sixteen. I saw some kids in my high school wearing custom sneakers and I thought *those are the coolest things.* I wanted a pair of my own. So, I taught myself—by watching videos and just practicing and practicing. And that's why I can tell you: *You can do this.* Remember, not all designs require drawing skills or special talents: You can come up with great designs that just use color blocking or marbled hydro dipping, or designs created with strips of tape that are later removed—you don't have to draw at all. And not all designs require painting with a brush either. I'll show you how to do some cool camo and doodling designs with pens.

Q: **Where do you get your inspiration?**

A: I just look around. If you don't already have a design in mind for your shoes, look at stuff you like—maybe it's a Vincent van Gogh painting. Maybe it's a favorite piece of clothing—you can see my bandana and plaid designs on pages 44 and 54. Your design doesn't have to be an exact copy of whatever it is you're looking at, just let it inspire your own creativity.

Or look at what other people have done. Artists inspire other artists—that's what we do. So go online. Look on Instagram or Etsy or Pinterest. Google hand-painted custom Vans or Jordans or Air Force 1s—whatever direction you're going. There's all kinds of inspiration out there. But here's the thing: Some of what's out there is so advanced, so inspiring, you'll get yourself in trouble if you try to do what those artists are doing before you're ready.

Know your level. If you're buying this book, you're a beginner or at the intermediate level of customizing—so stick with basic techniques and designs until you get the hang of them and then move on to the fancier stuff. You'll get frustrated and mess up if you try to do too much too fast. One step at a time.

Q: **A lot of the sneakers I see customized in photos cost at least $100. Can I get a cool look on shoes that aren't so expensive?**

A: Of course you can. You can customize anything you want. If it's got your style on it, it's going to be as fire as you are.

We'll talk about the different kinds of sneakers more in the Workspace, Materials, and Tools section coming up, but you just need to start with a clean pair of sneakers in any style and any brand you like: High-tops, lace-ups, slip-ons, canvas, or leather—it's your creativity and colors that make them cool, not the brand.

Personally, I don't have any experience working on shoes made out of synthetic materials. But the same companies that make the paints and supplies for painting on leather and canvas make paints and materials for painting on pleather too. You can use the same techniques described in this book—just use the right paints and follow the manufacturer's directions for prepping pleather materials.

Q: How long does it take to customize a pair of shoes?

A: I'm not going to lie to you: Customizing sneakers can be a slow process. First, there's that thing we just talked about—you've got to get good at your level before you can move on to the next level of expertise. That takes time. Just know that and be proud of what you can create at each level, and don't be too anxious to go too far too fast.

The other thing—you'll notice I repeat this throughout this book—is when you're applying the paint to your shoes, it has to go on in *thin, even coats*, one brushstroke at a time, and it's even slower on canvas shoes than on leather—but that's how this process works.

To get good paint adhesion that lasts forever, the paint has to go on thinly and evenly. Then it has to dry completely—and then you apply the next coat, and let it dry. And maybe there's a third coat. And that's just for the base color of the shoe. Then you get to start having fun adding the design elements. My bandana design shoes probably took me eight or nine hours over the course of several days. The more complex a design, the longer it will take.

So, know going in that it's going to take time and be cool with that. Put on your headphones, listen to some catchy music to keep you working, and watch your shoes transform one brushstroke at a time. Masterpieces don't happen overnight.

Q: What if the shoes I want to work on are not brand new? Can I still customize them?

A: Yes, you can. Even if your shoes have gotten muddied up, you can clean them and prep the surface for paint. I'll tell you how on page 19.

And here's something else to remember: When you're trying out a new technique, it's a good idea to try it on a pair of (clean) old sneakers first, just make sure you know what you're doing and that you're going to like the results.

WORKSPACE, MATERIALS, AND TOOLS

WORKSPACE

You'll need a clean, flat surface to work on. It doesn't have to be huge—it could be the kitchen table. But you do need space to store all your stuff: Paints and brushes, shoes in various stages of progress, heat gun or blow-dryer, airbrush and compressor, deglazers and finishes, craft knives, cotton balls—all kinds of stuff. Some products you'll be using, like deglazers and GAC 900, contain chemicals that could cause problems if they're not handled properly. So be sure to store your materials—and sharp tools like craft knives—in a place where little kids can't get into them.

CHOOSE YOUR SHOES

You already know there's no shortage of sneaker styles: High, low, slip-on, lace-up—your choice. Most customizing starts with a white sneaker, but it doesn't have to. Choose a shoe that matches your style and represents you. All the sneaker companies make styles that can be customized, but depending on the design you have it mind, certain silhouettes and surfaces give you more freedom. No secret, I love my Air Force 1s. You can't go wrong with them, but I also work on many other styles—Vans, Jordans, Converse—leather and canvas. And as we already talked about in the Q&A section, a no-name brand will work just as well as big-name brand.

Here's something to think about in choosing your shoe: If you want to do a lot of doodling and drawing, a canvas slip-on with no raised sections or swooshes or bumpy eyelets is going to give you a smoother open surface to draw on. But for another type of design, you're going to enjoy all those patches and eyelets and stitching. They'll give you extra elements to have fun with—you can use them to frame special details, contain blocks of color, or inspire doodling.

MATERIALS
Paints

The paints you're going to use on your shoes are acrylic, which is great, because acrylic dries quickly and washes up with just soap and water. BUT you can't use just any acrylic paint—you have to use acrylic paint specially formulated for leather and canvas.

Regular artists' acrylic paints are meant to be used on canvases that sit flat on a wall and never bend or move. The acrylic paints used for customizing sneakers have to adhere as smooth as skin to the surface of leather, and they have to be able to bend, stretch, and crease with the leather in your shoe without peeling or cracking. Similarly, the acrylics you use on canvas and mesh sneakers have to leave the fabric soft and flexible when it dries. Paints for customizing are developed especially to do all of that.

You can buy customizing paints and paint products at craft supply shops, online at the manufacturers' websites, and on Amazon.com. As some of you already know from my videos, I use Angelus paints for my work, but there are others to try as well.

Some of the brands for customizing on leather include:

- Angelus
- Creative Nation
- FineMade
- Magicfly
- Sevenwell
- Smalltongue

Acrylic leather paint comes in small jars. Most brands offer starter sets of six or a dozen colors at a good price. There are actually dozens of paint colors available and they can be hard to resist—but you don't need to go out and buy all of them. You can get going with the starter set and blend your own special colors. It's easy to do.

Deglazers

Customizing sneakers starts with removing the factory finish from your leather shoes. This is nonnegotiable—*you have to remove the finish before you start.* Paint manufacturers sell products called Leather Deglazer or Sneakers Deglazer that's made specially for this purpose. You can also use 100% acetone, which is what I use. It's available in hardware stores as a solvent and in drugstores, where it's sold as nail polish remover. (Note that not all nail polish remover is acetone-based—read the label to be sure.) See the "Prep and Finishing Basics" section on page 19 for more details on deglazing.

Fabric Medium

You can buy special fabric paints to use on your canvas sneakers, or you can use a liquid like GAC 900* to turn your acrylic leather paints into fabric paints—just mix the two at a 1:1 ratio. This mixture will work for canvas and mesh sneaker surfaces, as well as for sock liners.

GAC 900 contains formaldehyde.

Finishers

When you start your shoe customization, you remove the factory finish that protects the leather and prevents the shoes from getting banged up too soon. So, when you complete your customizing, you need to put a finish back on the shoes to protect the leather and your masterpiece. It's another nonnegotiable step.

All of the leather paint manufacturers offer acrylic finishers along with their other products. Finishers are liquids that you paint on with a brush—two coats—or apply with an airbrush in several thin coats. You can choose from matte, satin, and high-gloss finishes—or combine them. For instance, you might have a matte finish for the background color and high-gloss for the detailed work on a single shoe. Don't skip this step! After all the time and work you put into getting your custom just right, you need to protect the surface so you can wear your kicks for a long time without worrying about having the paint scuff off the first time you wear them.

Waterproofing Sprays

For some of your customs, especially with canvas sneakers, you might want to add an extra layer of protection—after the finisher goes on—by spraying on a coat of waterproofing. There are many waterproofing sprays available for use on leather and fabric. Angelus makes one called Water & Stain Repellent. Follow the manufacturer's directions for use and safety.

Airbrushing and Spray Paints

The same acrylic leather paints you apply with a brush in customizing are used for airbrushing, but they have to be thinned first or they will clog your airbrush. The companies that manufacture the paints also make the paint thinners. See "Airbrushing Basics," page 104, for more details.

Rust-Oleum spray paints, which are oil-based, available in a million colors, and sold in every hardware and big-box store, are also used in customizing. They give good coverage and are very flexible—the paint doesn't crack or peel when you wear your shoes. Rust-Oleum paints are used for hydro dipping, see page 94. You can also use them instead of airbrushing in some projects, although airbrushing gives you more control than a spray can. Rust-Oleum requires good ventilation while you're using it and acetone for cleanup.

Paint Pens

Paint pens contain oil paint, but you can use them like Sharpies—for drawing and doodling. In fact, you can buy them with different nibs, depending on whether you want to draw with a fine line or need a thicker line for coloring wide surfaces. Paint pens give you the same coverage on shoes as paint applied with a brush—in fact, in many customizing projects you can substitute paint pens for acrylics.

Because they're filled with oil paint, you have to shake the pens well before you use them. Then, when you begin to draw, you press down on the nib so the paint will flow. But if you press too hard, the paint comes out as a blob. So go easy on it. But what if you do end up with a big drip on your kicks? Just clean it up with a cotton swab dipped in acetone.

Oil paint takes a lot longer to dry than acrylic—you're going to want to let your shoes dry for a good twenty-four hours after you've painted them before you put the finish on or wear them. And don't cheat on the timing! You'll be kicking yourself if you wear your sneakers before they're 100 percent dry and the paint smears.

Make sure you have the windows open or a fan going when you're working with paint pens. Oil paints release fumes—so does acetone. Don't breathe in either one of them, and be sure to put the cap back on the acetone good and tight.

Lots of companies make paint pens for customizing your kicks. My favorites are Posca pens. They're inexpensive, you can buy them anywhere, they come in a million colors, and you can use them on everything: Shoes, walls, fabric, stone, metal, glass—just about any surface for any creative thing you want to do.

In customizing shoes, you can draw with paint pens on top of an acrylic base color—it doesn't matter that it's oil paint on top of acrylic. Same thing is true when you're done decorating—you'll paint your acrylic finisher right on top of the penwork once it's completely dry.

Markers

You'll have fun with Sharpies—in all colors. You can get a really good black-and-white look just by drawing with a black Sharpie on a leather shoe that's already been prepped. On a canvas sneaker, there's a chance the Sharpie ink (or even the ink of a fabric marker) might bleed a little into the fabric. But you can get around that by putting a light coat of paint on the canvas surface first, or spraying it with waterproofing fabric spray.

Sometimes, though, you might *want* the color to bleed and in the "Crazy Color" chapter, I'll show you how to get an amazing "tie-dye" color effect by using color Sharpies sprayed with rubbing alcohol on page 86. The alcohol spritz makes the colors run together and create new colors. It's a cool technique, and no drawing skills are required.

Mod Podge

Maybe you've seen this at craft stores. It's a thick, white liquid glue and sealer that you brush on. For customizing, I use it when I do a collage design with actual pieces of paper glued onto the shoe, sealing the collage with the Mod Podge.

Tape

You'll use tape for nearly every project. You'll use it to mask off areas of the shoe when you're working on a specific section and to protect the rubber sole of the shoe when you're working on the upper part. You'll use it when you're airbrushing and stenciling. And you'll use it when you're hydro dipping.

There are a lot of different kinds of tape out there, and different types are good for different purposes. Masking tape, for instance, works well for making templates when you need to trace certain shapes of your shoe (see "Fabrication Transformation," page 140). But despite its name, masking tape is not the best choice for masking parts of your shoes while you're painting. It's not sticky enough to make a good bond with the shoe surface for that purpose. You'll need a vinyl tape you can depend on to give you good, crisp lines between paint colors, not one that will allow the paint to seep underneath and smudge the lines.

Try out different kinds of vinyl tape to find what works best for you. My go-to tape is 3M's red vinyl tape. It does the job. For hydro dipping, some people like to use tape that's specially formulated for protection in water, such as FrogTape. For me, my red tape is just fine for hydro dipping and everything else.

Cotton Swabs, Cotton Balls, and Soft Cloths

Definitely keep a box of cotton swabs handy. You'll use them for a lot of things—from mixing paint to spot cleaning paint drips. And you'll need cotton balls and/or soft cloths for applying deglazer or acetone to remove the factory finish from your shoes. You'll need a supply of these for every pair of shoes you work on.

Toothpicks

I know this seems like a weird thing to include, but toothpick painting is one of my specialties, and you'll get to try it yourself. I'll show you how to do it on page 54. Keep a box of round toothpicks handy for doing any kind of fine detail work in your custom—it's cleaner and more precise than working with a tiny brush.

PREP AND FINISHING BASICS

I can't stress enough how important the prep is for customizing. If you don't clean the factory finish off the surface of leather sneakers before you begin, you're wasting your time and money because the paint will crack, it won't have a good bond, and your kicks are going to age poorly. As you'll see, every single custom in the book begins with prep.

LACES

The first thing you've got to do is take those shoestrings out. Even if you're not going to paint the section immediately around them, take them out and put them aside until you're done. It's not just because you don't want to splatter them with paint—they also keep the shoe too rigid when you're working. You want the shoe to be flexible, bendable, so you can get into all the tiny spaces and seams when you deglaze and paint.

DYK?
The same companies that make paint for customizing your shoes have paint that can be used for changing the color of your laces!

SURFACE CLEANING

You have a couple of choices for your prep of the shoe's surface. I use 100 percent acetone to clean the surface of the leather. You can buy it at any pharmacy-type store as nail polish remover or at a hardware store as a solvent.

The companies that make the paints for shoes also make their own products for cleaning the surface of the leather. They have names like Leather Preparer/Deglazer or Sneakers Deglazer. Buy them at the same places you buy your paints.

Use cotton balls or a soft cloth to apply the acetone/deglazer to the leather surface. That shiny finish is there to protect the leather from getting marked up—but we *want* to mark it up with our customizing, and we want the leather to absorb some of the paint so it stays permanently in place and doesn't peel or crack.

Apply the acetone methodically. Rub it in carefully. Make sure you get every single surface—around the eyelets, on the tongue, around the top edge of the shoe, and all along the seam where the upper part tucks into the midsole. Use a cotton swab for the small, tight parts.

Acetone dries pretty quickly, but give the shoes at least a half hour to dry after cleaning the surface. If there are any wet spots when you go to paint, that little bit of acetone will really mess things up. Let the shoes dry completely first.

The leather will have a soft, matte surface when the factory finish is gone—you can see it and feel it. But double-check, especially if you're doing this for the first time. When the shoes are dry, hold them under a light to check for any shiny spots you might have missed. If you find any, go back in with a cotton ball and a little more acetone, clean the finish off those spots, and let them dry again. It might seem like the prepping part takes too long, but it's worth it. You've got to do it. Take the time to do the steps right before you start your customizing.

Cleaning Muddy Sneakers for Customizing

Let's say you have a new pair of kicks and they end up covered in mud after kicking a soccer ball around a field with your friends for a couple of hours. Are they ruined for customizing? No way. You can get any dirty old pair of sneakers cleaned up.

I like to do this with a cleaning kit called Factory Laced Shoe Cleaner, which has everything you need. Angelus and other companies also have shoe-cleaner kits. Or you can give this a try with regular household products you might have around. For that you'll need a bowl of warm water, liquid dish soap, and shoe brushes with soft, medium, and stiff bristles.

To get started, take the laces and insole out of the shoe. Use a dry stiff brush to clean some of the dried mud off the surface. Have your bowl of warm water handy and mix in a few drops of liquid cleaner or dish soap. Dip a medium-bristle brush into the sudsy water and scrub your shoes all over. Use a harder bristle on the rubber sole. Keep cleaning until the mud is gone, and then use a soft bristle brush to rinse and smooth the surface.

Next, put those dirty shoestrings into sudsy water and handwash them until they come clean. Same thing with the insoles. Put those aside to dry.

Your shoes look as good as new now. Let the shoestrings and insoles dry completely—you want them out of the shoe anyway to prep the surface with acetone and cotton balls.

HEAD'S UP!
Let's Talk about Acetone

Removing the leather glaze is essential for customizing, and acetone is one of the best solvents for removing the factory finish—but it's a nasty chemical. You don't want to breathe it in. You don't want to let it sit on your skin. You don't want it around your eyes. You don't want it around little kids or your pets. And you don't want kids or pets around your discarded cotton balls either.

When you use acetone, be sure to work in an area with plenty of ventilation. If you can, prep your shoes outdoors. If that's not possible, work next to an open window—or at least with a fan blowing the fumes away from you.

When you're done, wash your hands. Put the used cotton balls in a small garbage bag and tie it closed. Dispose of the bag with your household trash. Then wash your hands again.

If you are using a branded deglazer product instead of acetone, be sure to read and follow the directions on the bottle for product safety and disposal.

TAPING

Once the surface of your shoes is cleaned and prepped, it's time to tape. I use my 3M red tape for this—use whatever kind of vinyl tape you like, as long as it's really sticky and waterproof.

Tape the parts of the sneaker where you don't want paint or inks to touch. For each section, press the tape down firmly to flatten it. Use your thumbnail to seal the edges and trace an outline of the shape.

Then use a craft knife to remove excess tape by cutting around the outline of the shape. Don't press too hard with the knife blade; just enough to cut the tape. You don't want to risk cutting the leather.

It's better to use too much tape than too little: You want to make sure that the taped sections stay clean under the tape.

HEAD'S UP!
Let's Talk about Taping
I know, some of you who've watched my YouTube videos are thinking, "Hey, Xavier, I've seen you painting some of your shoes without taping first."

Okay. You're right, but don't do that. Take the time to do the taping—it just takes a few minutes and you could be really sorry if you skip that step. The reason I sometimes skip taping is because I've been doing this for more than ten years, almost every day.

FINISHING

You take the factory finish off before you start customizing, and you put a custom finish back on when you're done customizing. Both of these steps are absolutely necessary—don't even think of skipping them, because your painted design will crack, peel, and get scuffed up in no time if you do.

Buy your acrylic finishers wherever you buy your paints— they're clear liquids that come in a bottle. You can use them on top of paint pen and Sharpie designs, as well as acrylic-painted surfaces, and you can choose between matte, satin, and high-gloss finishes. Matte or satin are probably the finishes you'll choose most often, but you could have some fun with high-gloss too, picking out details that will stand out against a matte background.

Apply the finisher the same way you apply your paint—two or three coats, drying each coat with a heat gun before you apply the next coat. Two or three coats means **at least two**—don't try to hurry and sneak by with only one coat. It's not enough. On the other hand, you don't want to add too many coats of the finisher because it can make colors appear darker than intended.

PLANNING YOUR DESIGN

DESIGNING

It's all about the design, right? Look around—there are so many directions you can go with this. Look at what other people have done, and get an idea of the kind of look you want for your kicks. If you've never done anything like this before, and you're not sure enough of your skills to approach a brand new pair of kicks with a wet paintbrush, there's an easy fix for that—grab a piece of paper and some markers or colored pencils and start practicing.

Pay attention to the sizes of the various sections on your shoes and how they're divided up: The toe box, the side quarters, the mudguard. (Yep, every part of a shoe has a name. Google "parts of a sneaker," and pretty soon you'll be adding "vamps" and "toe caps" to your vocabulary.)

Make sure your design elements or patterns are the right scale to fit the section you want to put them. Maybe you'll want to make the shapes in your design a little smaller, so they fit the space. And while you're at it, you can see what different colors look like next to each other.

For some designs, you might want wider spaces with no patches or swooshes breaking them up. For other designs you might like all the stitching and edges of the different sections and trims to frame in parts of the design or provide color-blocking areas. *The design has got to suit the shoe, so let the shoe be part of the inspiration.*

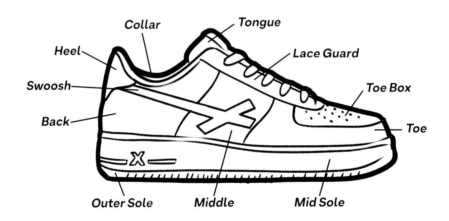

Collar • Heel • Swoosh • Back • Tongue • Lace Guard • Toe Box • Toe • Outer Sole • Middle • Mid Sole

PRACTICING YOUR BRUSHWORK AND PEN WORK

I had absolutely no experience with painting and drawing when I started customizing shoes. None. Maybe you haven't either. But there's a way to get completely comfortable with a paintbrush: Practice. A lot. Grab that sketchbook, maybe get an inexpensive set of tempera paints, and start practicing. You'll notice your confidence starts growing.

Practice the thin, even brushstrokes you'll use for the background color. When you paint an actual sneaker, you'll use tape to mask off the areas where you don't want any color—so you don't have to be the best painter in the universe, but you should learn to be precise, and to get just enough paint on the brush to make your strokes without leaving lumps and blobs.

One of the techniques I'll show you in this book is toothpick painting. Take a look on page 54, then practice that technique too before trying it on an actual shoe. Same thing for drawing with paint pens and Sharpies. If you haven't done much drawing before, you maybe don't want to try it for the first time on a brand-new shoe. Practice in your sketchbook.

Draw shapes and fill them in with color. And know your limitations: Work with geometric shapes and lines for your first designs while you get the hang of it. And, if it helps, when you're ready to actually work on your Air Force 1s or other shoe, outline your design lightly in pencil first on top of the background color. Then go over the lines with your paint pens or Sharpies.

WHY NOT?

Keep a sketchbook of your design ideas. An ordinary spiral-bound sketchbook can be like a design diary. If you think of or see a design you like, jot it down with some colored markers. Don't worry if you don't think you can draw. It doesn't have to be a great drawing (and no one else has to see it!). It can just be a doodled note to yourself: A shape, a pattern, a color combination that you might want to do more with later on.

Write down the date of your doodle and what you were doing when you had the idea for the design. It could be interesting to flip back though the sketchbook later to see how your ideas—and maybe your drawing skills—have progressed over time.

Customizing with
PAINT

The acrylic leather paints developed especially for customizing are amazing. The colors are great and give good coverage—two coats is almost always all you need, even though you'll apply the paints very thinly with each coat. Even plain white sneakers with some simple color blocking pop—and you can do so much more than that. In this chapter we'll play with painting with a brush and a toothpick, using tape with paint for geometric and striped designs, and creating fun color texture.

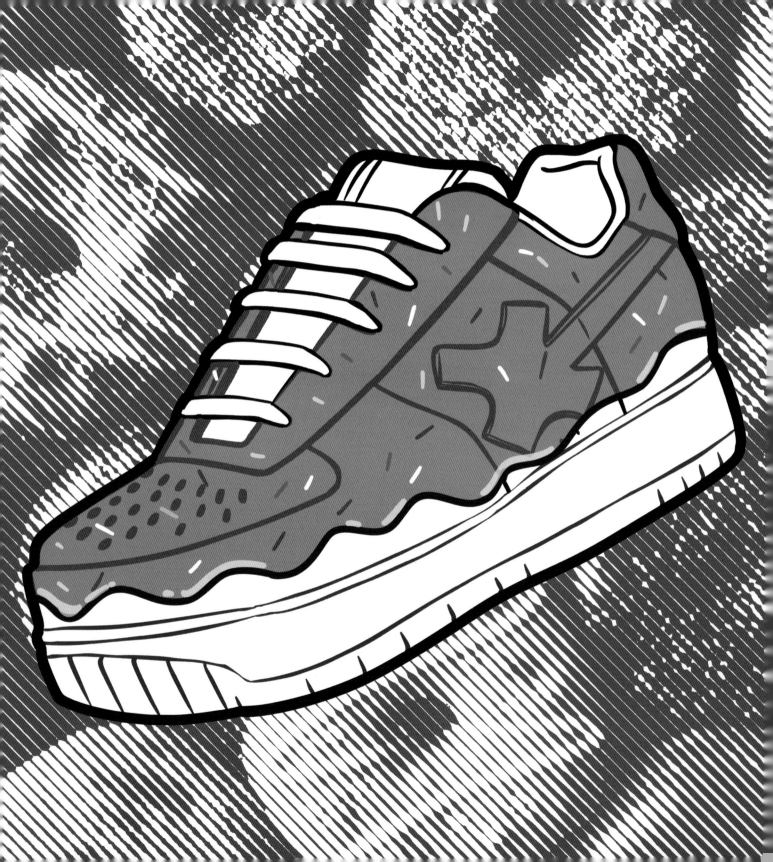

SPRINKLE DRIP KICKS

SCAN TO SEE A
TUTORIAL

These shoes remind me of a kid's birthday party. They look a little like cake frosting, or maybe donuts or melting ice cream with sprinkles. I made them for my niece who loves pink. One of the good things about this custom shoe is that once you do your prep, you go right into the paint—no taping. It's a quick and easy design, but very cool. It really stands out, and it's one custom sneaker that younger kids can help with.

I drew the wavy "drip" line all around each shoe in pencil first before painting. That's something to remember with any custom, especially if you haven't done a lot of painting before and you're not entirely comfortable with it. Once you've removed the factory finish from your shoe, the cleaned leather is easy to draw on with a pencil—you can sketch the different parts of your design and even erase the lines if you need to—so you'll know where you want every detail to go.

The "sprinkles" in this design can be added using a toothpick or a tiny detail brush. It's a good project for practicing your toothpick-painting skills, and you won't have to worry about rinsing out your brush between colors.

You'll need:
- **Leather sneakers**
- **Acetone** or **deglazer**—for prep
- **Cotton balls** or **soft cloth**—for prep
- **Pencil and eraser**—for drawing the wavy line
- **Acrylic leather paints**—hot pink for main color, black, blue, green, red, white, and yellow for the sprinkles
- **Paintbrush**—for the main color
- **Blow-dryer** or **heat gun**
- **Detail brush**—for wavy black line
- **Detail brush** or **toothpicks**—for the sprinkles
- **Acrylic finisher**
- **Brush**—for applying the finisher

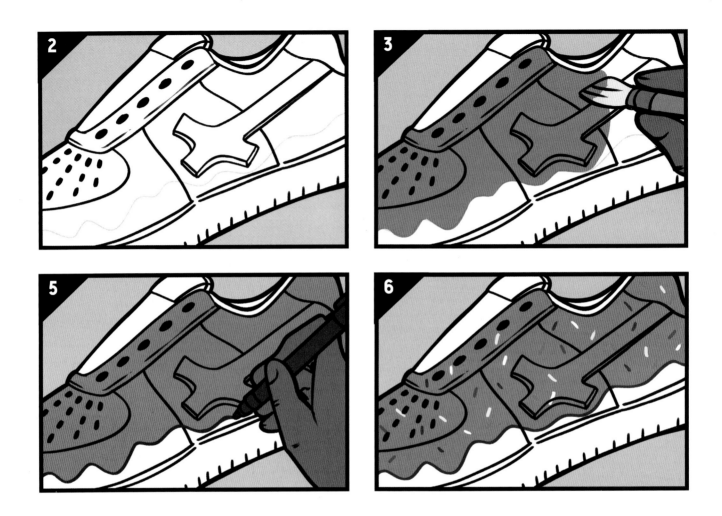

1. Start your prep. Take out the shoestrings and clean the entire surface of each shoe with acetone or deglazer and cotton balls or a soft cloth. If you haven't done prep before, see the details on page 19.

2. When the leather is dry, use the pencil to draw the wavy drip line all the way around each shoe. The two ends of the pencil line should match up to keep the continuity of the waves. Use the eraser if you need to adjust the line.

3. Start painting the pink background color using light, thin brushstrokes. Don't rush things and put the paint on too thick—just light and thin, no cheating. Cover the entire upper section of the shoe and follow the wavy pencil line smoothly. If it feels a little slow and tiresome, rinse out your brush and come back to it later to finish up.

4. Dry the first coat of paint with the blow-dryer or heat gun (on medium—no hotter). Repeat with a second coat of pink paint, drying the second coat as before.

5. Highlight the wavy line by outlining it, using the detail brush and black paint. The black line really makes the design crisp.

6. Now for the fun part—adding the sprinkles. Dip the toothpicks or detail brush into each color and paint tiny lines on top of the pink background. If you're using toothpicks, you can alternate among the colors. If you're using a detail brush, paint all of one color first, then rinse your brush thoroughly and paint all of another color—and so on—until all the colors are sprinkled on. One coat of paint should be enough for the sprinkles.

7. Blow-dry the sprinkles, then add your finish coat. Paint on a light coat of acrylic finisher, blow it dry. Repeat with another coat and blow-dry again.

WHY NOT?
Practice in Your Sketchbook First
If you haven't done much painting before, do yourself a favor and pull out that sketchbook or scrap paper we talked about on page 25, and practice painting a thin, wavy line—just so you know how much pressure to apply to the brush as you move it along the line. Then break out your box of toothpicks or your detail brush and practice making tiny "sprinkles" of color.

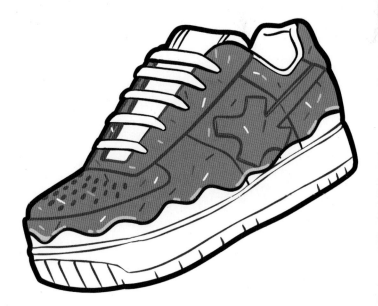

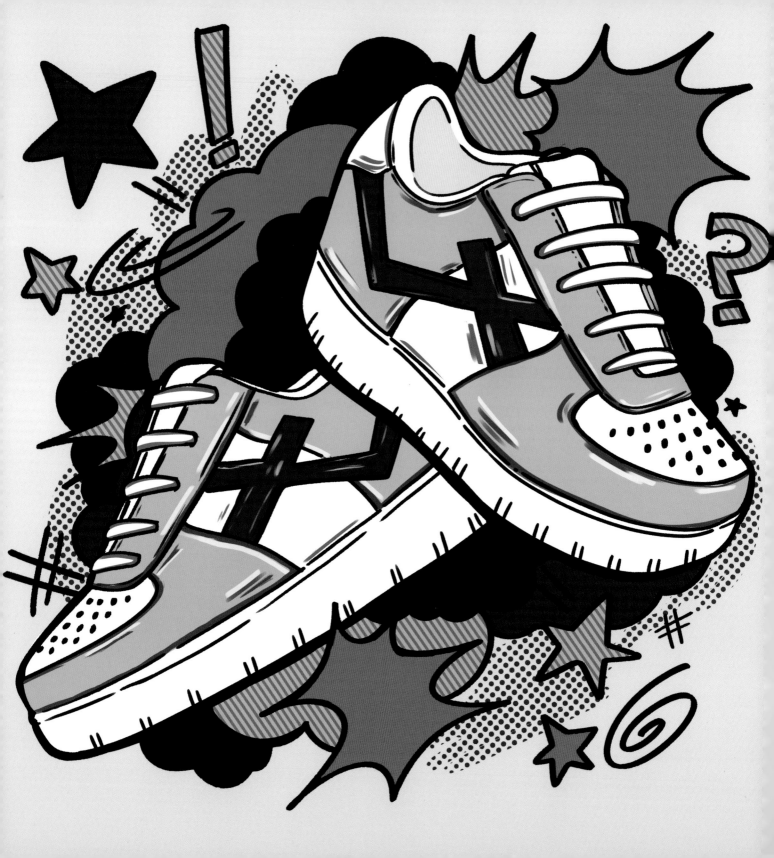

CARTOON KICKS

SCAN TO SEE A
TUTORIAL

This is one of the most popular styles of custom sneaker out there. It's so retro—like a cartoon version of a classic two-toned shoe, right down to the perforations on the toe.

I painted this pair of Air Force 1s entirely by hand with a brush, but you could make the process a little easier and get the same effect by painting the blue areas with a brush, and then adding the black and white detail lines with fine-point paint pens.

This project is definitely a good one to practice in your sketchbook. Take a look online for other cartoon custom sneakers—there are lots of them, with all kinds of variations and colors. Look closely at how the black-and-white detail lines are added. In part, they provide the outlines every part of a cartoon has. But some of the curved lines also give the shoes the look of motion—they're the cartoonist's way of showing that the character wearing them is moving. Try drawing the shoes in your sketchbook and get a feel for where the lines should go—you want to get that cartoony feel, but not overdo it with too many lines.

You'll need:
- **White leather sneakers**
- **Acetone or deglazer**—for prep
- **Cotton balls** or **soft cloth**—for prep
- **Vinyl tape**—for protecting unpainted areas of the shoes
- **Scissors** or **craft knife**—for cutting the tape
- **Acrylic leather paints**—three colors of your choice *(I used turquoise, black, and white. Alternatively, use black and white fine-tipped paint pens for the details.)*
- **Flat-tip paintbrush**—for painting the background color
- **Blow-dryer** or **heat gun**
- **Tiny detail brush**
- **Acrylic paint finisher**
- **Paintbrush**—for finisher

1. Start with your prep. Take out those shoestrings and set them aside. Clean every surface of the shoes with the acetone or deglazer and cotton balls or a soft cloth. If you *haven't* done prep before, follow the directions on page 19.

2. Taping is next. Tape every surface of the shoe that you don't want the paint to touch. I use 3M red vinyl tape; use what works for you.

3. Apply the first coat of turquoise blue paint (or the color of your choice) in very light, thin strokes. Blow it dry with a heat gun or blow-dryer. Apply a second coat of turquoise and dry it again.

4. Apply the first coat of black paint to the swoosh in light, thin stokes. Blow it dry. Apply a second coat of paint and dry it again. Remove the tape.

5. Begin your detailing. I started by painting sections of white outlines near the stitching in different areas of the shoe. I did not try to make continuous outlines all along the stitching—I let my white lines break naturally. Allow the white paint to dry thoroughly.

6. Next add black detailing. In some sections I made black highlights next to the white lines. I also added black outlines along the seam where the sole of the shoe joins the upper, and carefully outlined the edges of each colored section, the eyelets, and some of the punched holes to make them pop too.

7. Sit back and look at your shoes. Are there just enough cartooning lines? Not quite enough? I added a few curved lines around the swoosh to create that sense of motion.

8. When you've got the balance just right, allow the shoes to dry thoroughly.

9. Paint on a light coat of acrylic finisher, blow it dry, and then repeat with another coat and blow-dry.

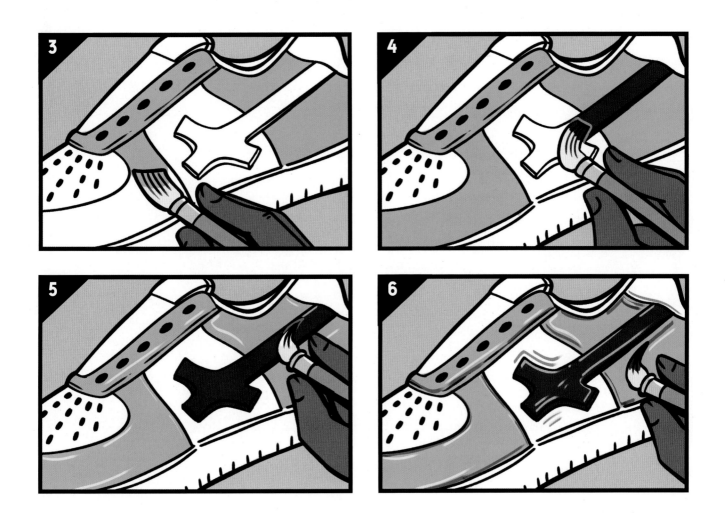

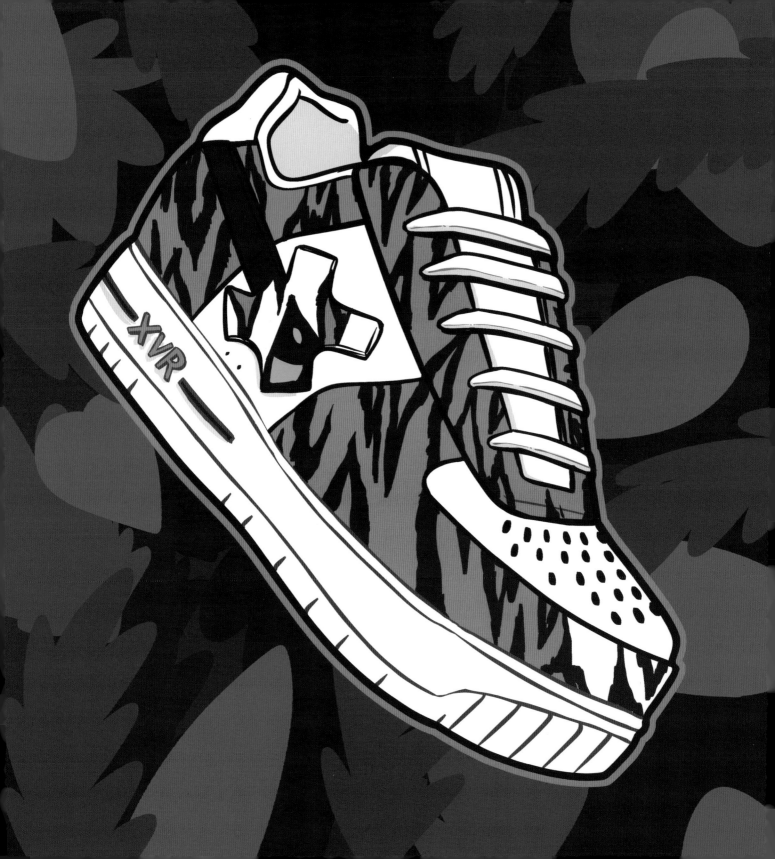

TIGER STRIPES

SCAN TO SEE A
TUTORIAL

In the "Planning Your Design" section on page 24, one of the things I talk about is how "the design has got to suit the shoe, so let the shoe be part of the inspiration." And that's exactly what I'm doing with this custom sneaker.

You can do a tiger-stripe design on any pair of shoes you like, but these Air Force 1s have a toe box and a swoosh that I incorporated into the design. I used the swoosh shape to help change up the pattern and switch over from painting the tiger's stripes to painting the tiger's green eye looking out at you. I think that little bit of light, bright green contrast helps make the whole design pop. Leaving some areas of white under the swoosh and on top of the toe box helps break up all that intense orange color.

You could do this custom shoe with any animal print—zebra, giraffe, cheetah—always painting the darker colors on top of a lighter background. I painted this design completely freehand, adding the black stripes with a detail brush over orange acrylic. But, as always, you could do the whole custom with paint pens, or airbrush the orange areas and then go back in with a brush or pens to add the black stripes and the bright green eye.

You'll need:
- **White leather high-top sneakers**
- **Acetone** or **deglazer**—for prep
- **Cotton balls or soft cloth**—for prep
- **Vinyl tape**—for protecting unpainted areas of the shoes
- **Scissors** or **craft knife**—for cutting the tape
- **Acrylic leather paints**—tangerine, black, light green
- **Flat-tipped paintbrush**—for background color
- **Blow-dryer** or **heat gun**
- **Pencil** (optional)
- **Detail brush**—for tiger stripes and eye
- **Acrylic finisher**
- **Paintbrush**—for finisher

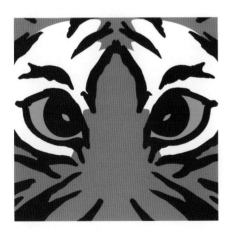

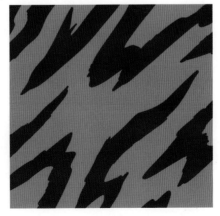

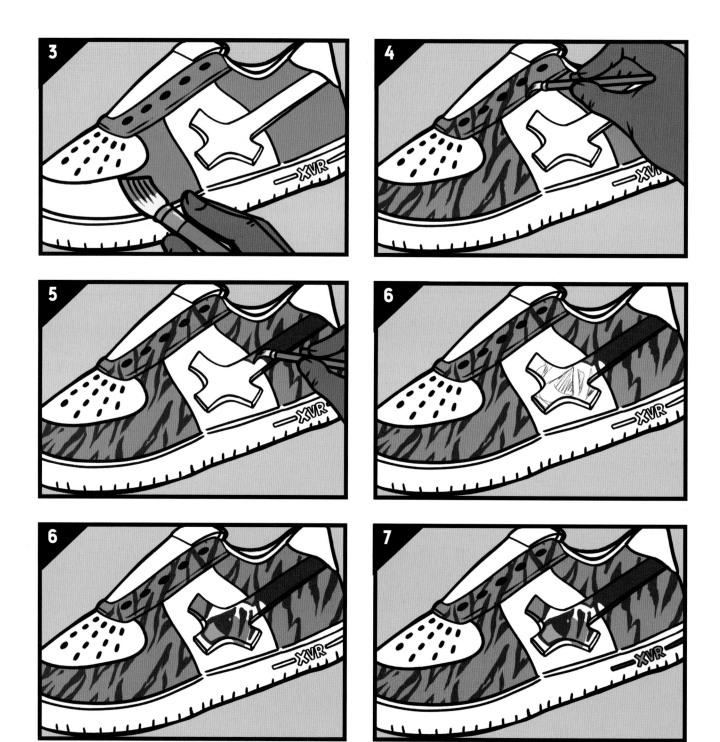

1. You know the drill. Start with your prep. Get those shoestrings out of there and then clean the entire surface of the shoes with acetone or deglazer and cotton balls or a soft cloth.

2. Decide what areas of the shoe you want to leave white. For my shoes that's the toe box and front of the toe, tongue, back seam and heel tag, midsoles, side quarters, and the entire swoosh. Tape those areas carefully. If you need a refresher, read the section on taping on page 22. I use 3M red vinyl tape; use what works for you.

3. Using a brush and tangerine paint, give all the open surfaces a light coat of paint. Dry the first coat with a blow-dryer or heat gun. Paint and dry a second coat. Two coats of tangerine paint should be enough, but if the paint looks thin in any area, apply a third coat. The orange color should be completely smooth and even.

4. Now paint the stripes using black acrylic and a detail brush. You'll find lots of pictures online if you need a reminder of what tiger stripes look like. If it helps, use the pencil to sketch the placement of stripes on the shoe. Try painting stripes with the detail brush in your sketchbook or scrap paper before painting them on your shoes.

5. Remove the tape from your shoes. Using the black acrylic and brush, paint the narrow half of the swoosh black. I added a few bits of orange to complete the look of the stipes.

6. Take a look at photos of a tiger's face. Use the color of its eyes and the fur around its eyes to inspire a design on the curve of the swoosh. Draw it in pencil first, if it helps, then paint it using a detail brush in tangerine, black, and light green.

7. For a final touch, use the detail brush to highlight the logo on the midsole in tangerine and black.

8. When your tiger design is completely dry, brush or airbrush two coats of finisher over your painting, drying each coat with the blow-dryer or heat gun.

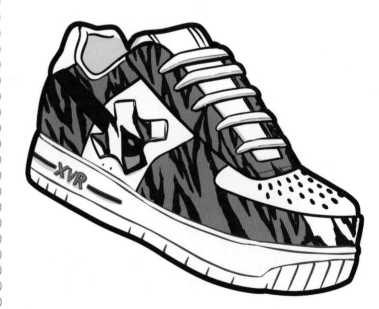

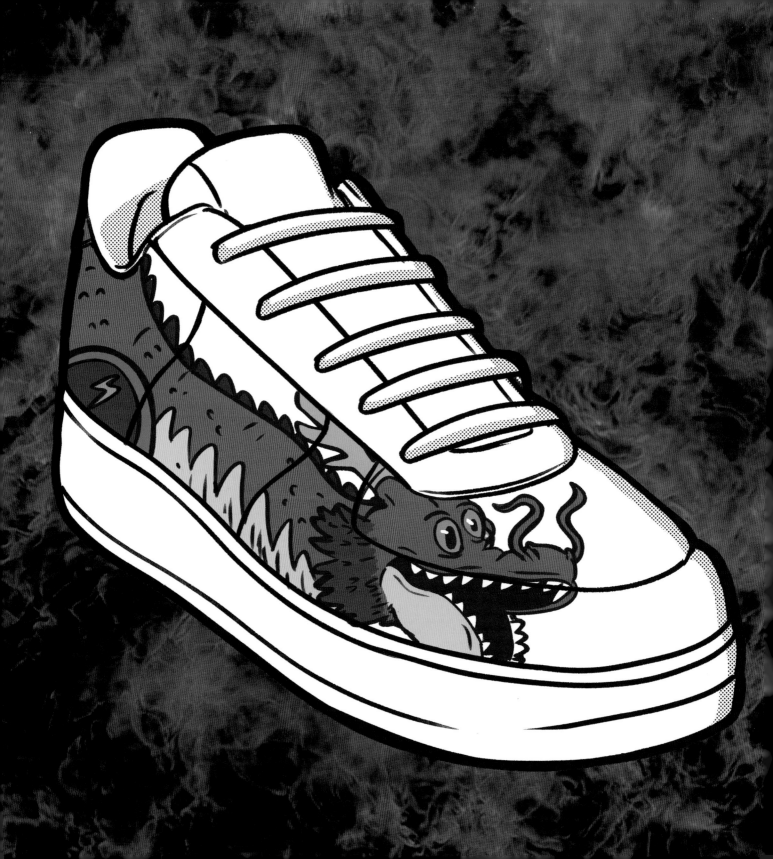

DRAGON KICKS

SCAN TO SEE A
TUTORIAL

So far, we've talked about all kinds of customs where you paint the entire shoe, starting with a background color, but you don't have to go that way. If you have a favorite image you want to walk around with or an icon that represents who you are, you can make that the focus of your custom like I did with this dragon—actually, I was thinking of doing an alligator, but I ended up drawing a dragon instead!

Draw your design in pencil on the shoe before painting it. Maybe sketch it on paper a few times until it's just the way you want it. Creating a design you can break into separate outlined areas of color will make it easier for you to paint. For instance, my dragon has separate sections of light pink, dark pink, blue, purple, and turquoise, but you could use whatever color combination you want. After I painted the individual colors, I outlined the sections with fine black lines to make them stand out. I painted my dragon with acrylic paints and small brushes, including a very small detail brush, but you could get the same look using paint pens for both the solid colors and the details.

You'll need:
- **Leather sneakers**
- **Craft knife** or **seam ripper**—for picking out stitches to remove the swoosh
- **Tweezers**—for pulling out stitches
- **Acetone** or **deglazer**—for prep
- **Cotton balls** or **soft cloth**—for prep
- **Pencil**
- **Acrylic leather paints**—light pink, dark pink, blue, dark blue, purple, turquoise
- **Small flat paintbrush**
- **Tiny detail brush**
- **Blow-dryer** or **heat gun**
- **Acrylic finisher**
- **Brush** or **airbrush**—for applying finisher

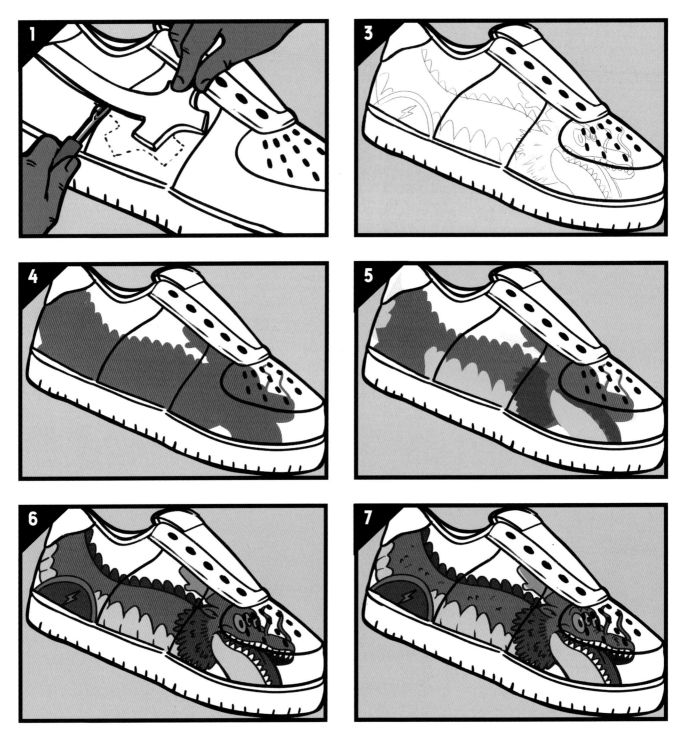

1. The first part of the prep for this custom is to remove anything like a swoosh from the sides of the shoes. Use the point of a craft knife or a seam ripper to carefully pick out the stitches. Then use the tweezers to pull out any remaining threads. If your design isn't going to bump into the swoosh, you can skip this step.

2. You only need to remove the finish on the part of the shoe you'll be painting. Clean the area you will be working on with acetone or deglazer and cotton balls or a soft cloth.

3. Use a pencil to draw your design on the cleaned leather. Clearly define the sections for each different color—it will help you when you start to paint.

4. Choose your first color and paint those areas of your design. Blow-dry the first coat of paint. Brush on a second coat and blow-dry again.

5. Rinse your brush and repeat step 4 with each additional color.

6. Use a tiny detail brush and black paint (or a fine-point Sharpie) to carefully outline each section of color.

7. Rinse the brush and go back in to add any small details.

8. When it's thoroughly dry, brush or airbrush two coats of finisher over your painting, drying each coat with the blow-dryer or heat gun.

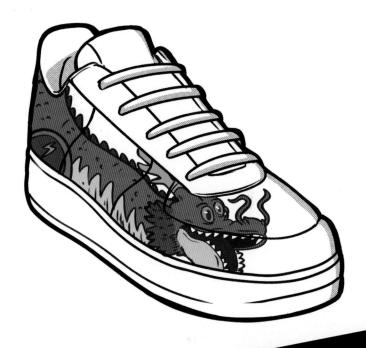

DYK?
In videos, you'll often see designers removing the swoosh from sneakers before painting their designs. This gives them a smooth area to paint on. To do this, carefully insert the point of a craft knife blade under a stitch and slice it. Then move to the next stitch and the next. Another tool that makes this process faster is a seam ripper, which is designed for exactly this purpose and can be found at fabric stores and craft stores for about a dollar. Once you've cut all the stitches around the edge of the swoosh, pull it off. Then go back and use the tweezers to pick out the cut threads remaining on the shoe. **BTW,** don't even think about cutting any other stitches on your shoes! The swoosh is non-structural—it doesn't hold the shoe together, but the rest of the stitches in your shoe do!

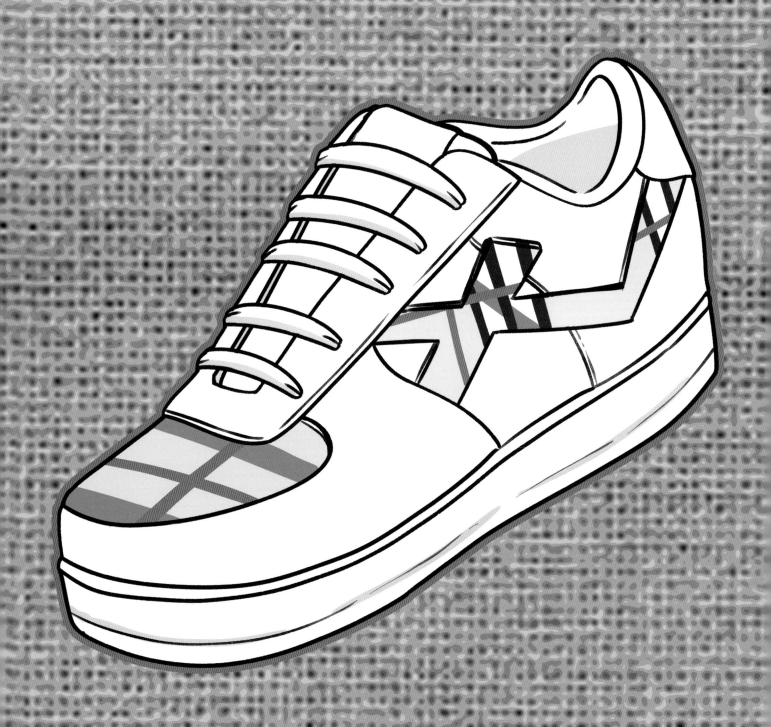

PAINTED PLAID

SCAN TO SEE A
TUTORIAL

As mentioned in "Prep and Finishing Basics" on page 19, getting your taping skills down is something you'll need all the time in customizing—and this project will help you sharpen those skills. You can do this plaid in five colors on any white leather sneaker.

This look is clean, and there are no drawing skills necessary—the whole design is created using the straight edges of the tape to make the painted stripes of the plaid. The different color stripes go both vertically and horizontally, so as you work, make sure each stripe of color you apply is *completely* dry before you remove the tape and put down new tape for a stripe going the opposite direction—otherwise, when you remove the tape, you'll pull up the paint with it.

If you want to recreate that famous Burberry plaid, have a picture of it nearby to reference, but (and I'll remind you of this in other projects in this book too) don't worry about copying anything exactly—just let it inspire you to create a plaid version of your own.

You'll need:
- **White leather sneakers**
- **Acetone** or **deglazer**—for prep
- **Cotton balls** or **soft cloth**—for prep
- **Vinyl tape**—for protecting unpainted areas of the shoes
- **Snap-blade knife** and **ruler**—for cutting the tape
- **Surface for cutting**—cutting board or ceramic tile, for instance
- **Acrylic leather paints**
- **Blow-dryer** or **heat gun**
- **Paintbrushes**
- **Tiny detail brush** or **toothpick**
- **Acrylic finisher**—matte finish
- **Brush**—for applying the finisher

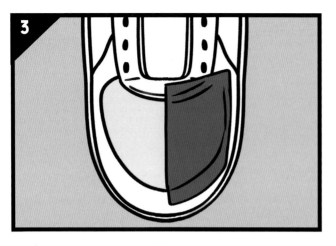

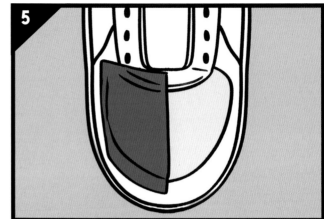

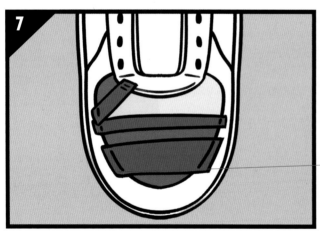

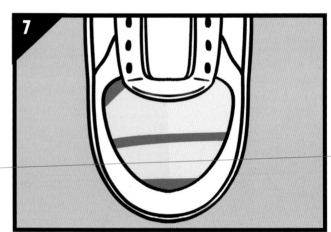

1. As always, start with your prep. Take out the shoestrings, then clean the factory finish off the surface of your shoes completely using acetone or a deglazer on a cotton ball or soft cloth. If you haven't done prep before, follow the directions on page 19.

2. Decide where you're going to paint the plaid on your shoes. I'm doing just the toe box (the section on top of the toe area) and swoosh on mine. Tape carefully around the sections you'll be painting to protect the neighboring areas from paint splatters. I use 3M red vinyl tape; use what works for you.

3. Stick down a piece of tape to divide the toe box into left- and right-hand halves. Start by painting the left-hand side of the toe box with the background color. Use light, thin strokes to brush on the background.

4. Use the blow-dryer or a heat gun (on medium) to dry the first coat of paint. Then apply a second coat of paint in light, thin strokes, and dry it. When it's completely dry, pull off the tape.

5. Stick down a new piece of tape along that same left/right dividing line, but this time on the other side of the line. Paint two coats of a different color paint on the right-hand half of the toe box, drying the paint with the blow-dryer or heat gun after each coat. Remove the tape and you have a perfectly divided toe box.

6. Now you'll make narrow horizontal stripes. This is where your taping skills will be put to use.

7. Apply strips of tape horizontally across the toe of the shoe to make three stripes, evenly spaced, and each about ¼-inch wide. Paint the stripes—two coats, drying after each coat. (A rule of thumb when you're customizing is that you can paint darker colors right on top of lighter paint colors.) Remove the tape when the paint is completely dry.

(continued on next page)

HANG ON A MINUTE

You'll use narrow strips of tape to mask off sections when you're painting the stripes. For the stripes to look professional, the tape strips need to be perfectly straight. The best way to ensure they are to cut the tape using a sharp snap-blade knife and ruler. Roll out a 5-inch piece of tape and stick it onto a hard surface, like a cutting board or a ceramic tile. Line up your ruler, and slice the tape into ½-inch-wide strips. Repeat with another piece of tape. Use the narrow strips as you need them, cutting them even narrower or shorter when needed.

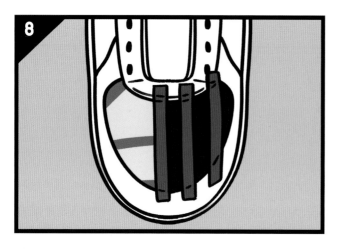

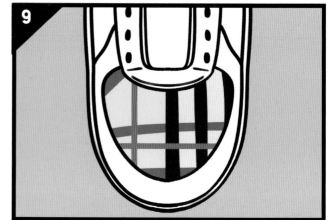

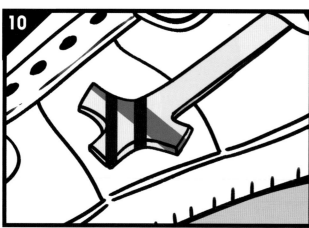

8. Apply tape to make three ¼-inch-wide vertical stripes—one down the center of the toe box and two to its right. Paint these stripes—two coats, drying after each coat, and as always, applying the paint with light, thin brushstrokes.

9. Tape again to make one skinny (⅛-inch-wide) vertical stripe down the left-hand section of the toe box—two coats, drying after each coat. Then do the same horizontally, toward the front of the toe. The toe box is done.

10. Tape the swoosh to create four sections that will alternate your background colors: A 1-inch section at the narrow end; a 1½ -inch section next to it; a 3½-inch section in the middle; and finally the curl of the swoosh.

11. Apply short pieces of tape to make alternating vertical stripes over the background, painting each short stripe with two coats, drying after each coat. Remove all the tape and you're done painting the plaid!

12. For a little added pop of style, use a tiny detail brush or a toothpick to color in the shoe's logo on the midsole.

13. Finally, get out your acrylic finisher, paintbrush, and blow-dryer, and when the paint on your shoes is completely dry apply two coats of finish, drying after each coat. Guys, yo! Your shoes look fire!

DYK?
This design takes a little time because all the different layers of colors have to dry individually, but this project is actually so simple and so clean, it's easy. You can do it.

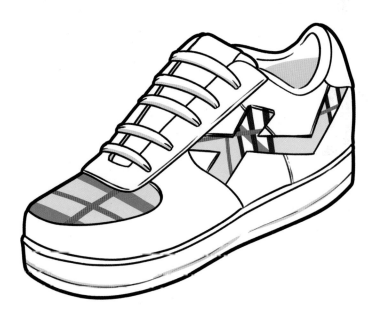

FREESTYLE HIGH-TOPS

SCAN TO SEE A
TUTORIAL

Are you feeling ready to test your painting skills to the limit? Then this may be the custom for you. I painted these shoes freestyle with a flat brush for the background and a detail brush for the linework—any color combination you like would work.

I love the way these turned out—it was tough, and I enjoyed this project a lot, but it definitely took a little minute. So don't set a time limit for yourself. Once you get the large areas of color painted, just put on some music and come back to painting the linework a little bit every day. Of course, to get a similar look faster, you could do all the linework in black Sharpie.

I decided to go with a white high-top sneaker for this custom because the different parts of the shoe and stitching give you a lot of interesting shapes to work with. I think the black-and-white areas on these shoes have such a bold impact that they really set off the color and the finer linework. Think about the different shapes that are already there in the leather of whatever shoes you are working on, and use them as part of your design.

You'll need:
- **White leather high-top sneakers**
- **Acetone** or **deglazer**—for prep
- **Cotton balls** or **soft cloth**—for prep
- **Vinyl tape**—for protecting unpainted areas of the shoes
- **Scissors** or **craft knife**—for cutting the tape
- **Acrylic leather paints**—light green, black (or black Sharpie)
- **Flat-tipped paintbrush**—for background color
- **Blow-dryer** or **heat gun**
- **Detail brush**—for linework
- **Acrylic finisher**
- **Paintbrush**—for finisher

HANG ON A MINUTE

I decided to doodle my linework with a kind of leaf and flower design, but you could do anything you like. A spiderweb design would be cool, or geometric shapes, tattoo designs, architectural shapes—choose a doodle that suits you. For extra confidence, draw your design in pencil on the painted background first, then go over your pencil lines with paint.

1. As always, the first thing you've got to do is prep. Pull out the shoestrings and set them aside, then carefully go over all the surfaces of each shoe with acetone or deglazer and cotton balls or a soft cloth. If you haven't done prep before, see the details on page 19.

2. Tape the midsoles to keep them clean while you're painting. I use 3M red vinyl tape; use what works for you.

3. Plan your design. Know ahead of time where you want your black-and-white contrasts and where you want your bright pops of color.

4. Paint all the areas of your lighter color first—on my shoes, it's the light green. Dry the first coat with the blow-dryer or heat gun. Apply a second coat of paint and dry again.

5. Repeat step 4 with the black-painted areas. Then you're ready to start painting your linework.

6. Dip the detail brush into the black paint and begin your design. I began at the toe of the sneaker and worked upward toward the tongue. Then I moved around to the sides and heel of the shoe. Slowly, slowly. Paint the outline of the shapes and then go back and fill in the fine details and solid areas. Any time you feel yourself getting tired, put the shoes aside, clean your brush, and come back to it later.

7. When the linework is completely dry, get out your acrylic finisher, paintbrush, and blow-dryer. Give the shoes two coats of finish, using the blow-dryer or a heat gun to dry the finisher after each coat. I think you've got to agree, the time you spent on this custom was worth every minute!

WHY NOT?
Pull Out That Sketchbook

As I mentioned earlier, this custom will require a big investment of your time, so you want to be sure it comes out exactly the way you want. The best way to do that is to sketch it out on paper first. Draw the outline of the entire shoe and all of the stitched sections of the shoe. Then get out your markers or colored pencils and decide which colors go where—like a roadmap for your painting. When you get the balance of contrasts just right, you're ready to paint.

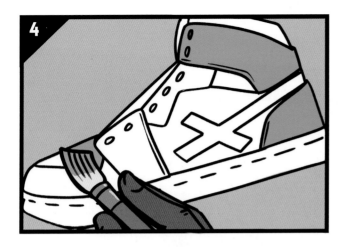

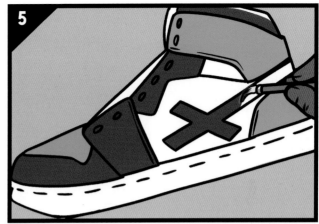

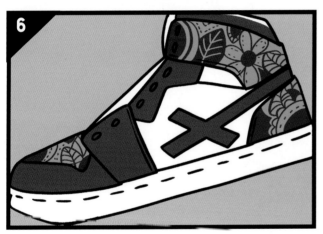

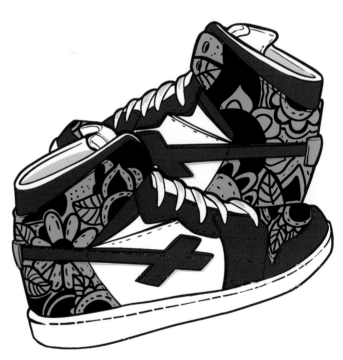

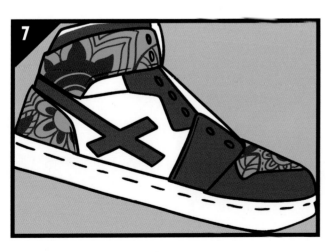

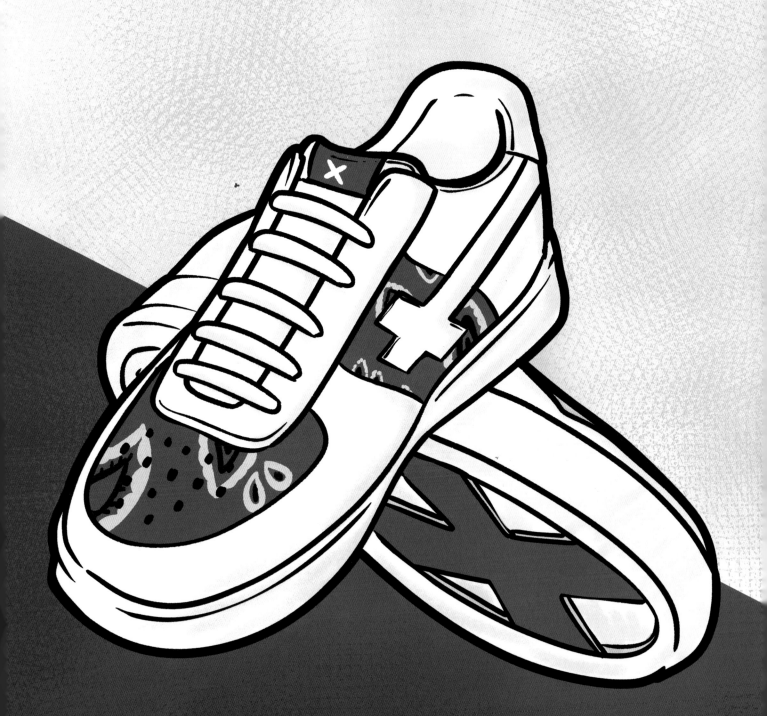

TOOTHPICK PAINTING

SCAN TO SEE A
TUTORIAL

I thought this technique was crazy the first time I saw it. It's not something I ever thought I'd be doing in my whole journey with custom sneakers. This process involves toothpicks, like the ones you have in the kitchen cupboard that you can buy anywhere for about a dollar. With toothpicks, you can draw with paint like a fine-tip marker. I thought I'd try something a little different with my design this time, using a bandana for inspiration.

The important thing to know, if you hadn't noticed before, is that there are two kinds of toothpicks: Flat and round. You want the round ones for your custom work: They're sturdier, easier to hold on to, and they come to a sharp point. You can also sharpen the points even finer with an emery board or sandpaper if you need to.

For this custom, once we get the background color down, we're going to do the whole design with toothpicks. But keep a box of them around for your other projects too. They are the best tool for doing any tiny detail work—better and a whole lot cheaper than a brush. You'll use them all the time.

You'll need:
- **Leather sneakers**
- **Acetone** or **deglazer**—for prep
- **Cotton balls** or **soft cloth**—for prep
- **Vinyl tape**—for protecting unpainted areas of the shoes
- **Scissors**—for cutting the tape
- **Bandana**—for reference (optional)
- **Acrylic leather paints**—the color of your choice for the background color and flat black and white paints for the bandana design details
- **Flat-tipped paintbrush**—for the background color
- **Blow-dryer** or **heat gun**
- **Box of round toothpicks**
- **Acrylic finisher**
- **Brush**—for applying the finisher
- *Have **cotton swabs** and **acetone** on hand too, in case you need to clean up any drips.*

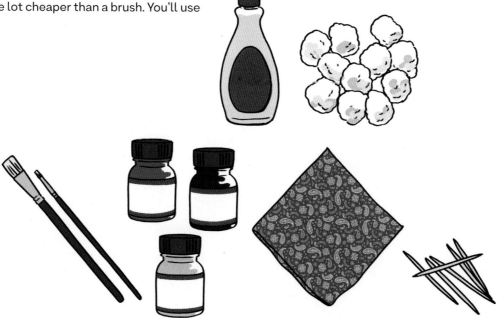

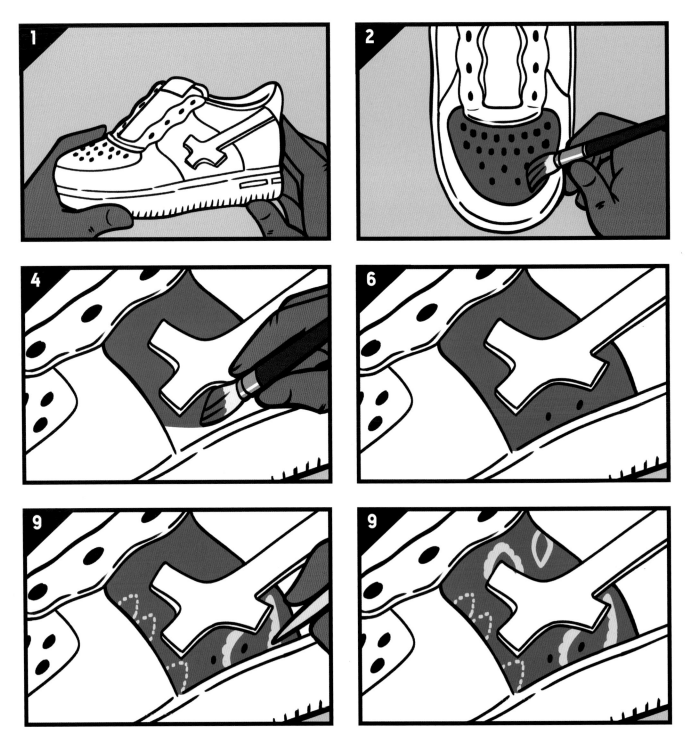

1. Pull out the shoestrings, set them aside, and start your prep. See page 19 if you need a reminder how to do this. Make sure you go over every part of each shoe with acetone or deglazer and cotton balls or a soft cloth, and get rid of that factory finish so your paint will stick.

2. Decide where you want your bandana design to go. I'm going to do mine on just the toe box (on top of the toe area) and on the side quarters. You could do the whole shoe in a bandana design if you want.

3. Tape around the sections you'll be painting. If you'll be painting near the midsoles, tape those too, to keep them clean. See page 22 if you need a reminder about how to tape. I use 3M red vinyl tape; use what works for you.

4. Paint the first coat of your background color. Pour a little paint into the bottle cap, dip in your brush, and then apply the paint—thinly. If the paint goes on too thick in a single coat it could peel later. You'll apply two coats of the background color, so don't worry if the first coat looks a little transparent in places.

5. Dry the paint with a blow-dryer or heat gun. If you're using a heat gun, keep the heat at medium, otherwise it can get too hot. You have to be careful with heat temperature around paint—don't overdo it.

6. Paint and blow-dry a second coat of background color. It should be looking really good now, and you're ready to go in with your toothpicks.

7. You might want to have an actual bandana on hand, so you can refer to it for the kinds of shapes and lines you'll be drawing, but don't worry about copying the design exactly—just use it for inspiration. Most bandana designs include some larger paisley shapes. Outline those larger shapes on your shoe first, then go back and add the scalloped borders to the paisley shapes and any other little dots and tiny teardrop shapes you want.

8. Get out your box of toothpicks. Pour a little black paint and white paint into the bottle caps.

9. Dip a toothpick into one of the paints—not too deep—and start drawing the first paisley shape on your background, a little bit at a time. Keep going back and re-dipping as your design inches along. Make your lines as thin as possible—you can always go back in and thicken the lines afterward.

(continued on next page)

WHY NOT?
Get Out That Sketchbook or Scrap Paper
Practice drawing with a toothpick and paint. Pour a little paint into the bottle cap and dip the tip of the toothpick into it—not too deep. Then draw with the toothpick, making as fine a line as possible and re-dipping the tip into the paint as needed. Practice the paisley shapes that you find on most bandanas. It's not hard—it just takes a little getting used to.

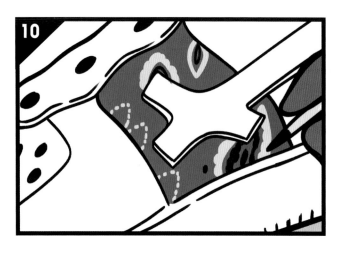
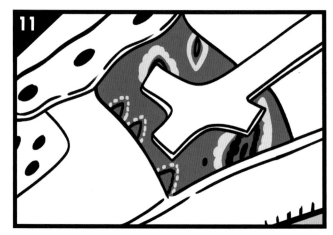
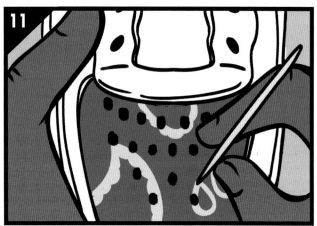
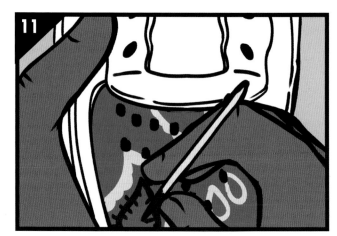

10. Alternate black and white shapes as you go along with your design—that will help make each shape really pop visually. You'll start to see the overall design coming together.

11. Little by little, you'll cover your background color with those characteristic black-and-white bandana design shapes—just enough of them. Those fine lines of paint will dry very quickly, and you're ready for your finish.

12. Remove any tape on your shoe. Get out your acrylic finisher, paintbrush, and blow-dryer and give your shoes two coats of finish, using the blow-dryer or heat gun to dry the finisher after each coat.

Paint Pen
COLOR

Paint pens might end up being your absolute favorite customizing materials. When you want, you can use them for line drawings, doodles, and cartoons—or even with a straight-edge for geometric designs. But, as you'll see in this chapter, oil-based paint pens can produce the same look as painting with a brush—with a lot more control. Some paint pens are available with a range of nibs, from fine-tip to wide, giving you great flexibility in your projects.

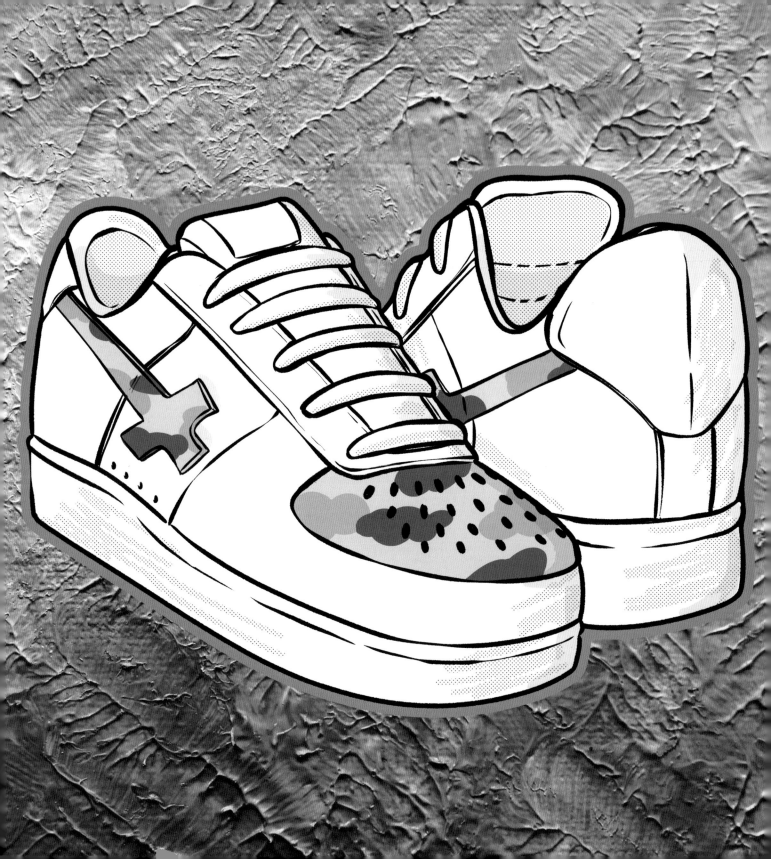

PAINT PEN CAMO

SCAN TO SEE A
TUTORIAL

I know you've been wanting to try working with paint pens, so let's ease into it. We'll start with a three-color camo design you can do even if you're not completely confident about your drawing skills.

I love working with paint pens even more than regular painting. You can read all about them in the "Workspace, Materials, and Tools" section, page 14. My favorites are Posca pens. They come in a million bright, beautiful colors, you can buy them anywhere, and you can use them on any kind of shoe. Use them on your Vans, use them on your Crocs—today, I'm going to use them on a pair of Air Force 1s, so the instructions are for working on leather. (If you go with canvas shoes instead, mix the leather paints 1:1 with GAC 900, and skip the prep in step 1.)

There are many different kinds of camo designs, and it's a good idea to create them with colors that blend well. For this custom, I found three shades of blue I like together: pale blue for the background and two darker shades for the camo spots. You're going to apply two coats for the background color and two coats of each camo color.

You'll need:
- **Leather sneakers**
- **Acetone** or **deglazer**—for prep
- **Cotton balls** or **soft cloth**—for prep
- **Vinyl tape**—for protecting unpainted areas of the shoess
- **Scissors** and **craft knife**—for trimming the tape
- **Paint pens**—three colors of your choice
- **Blow-dryer** or **heat gun**
- **Acrylic finisher**
- **Brush**—for applying the finisher
- *Keep some **cotton swabs** and **acetone** on hand too, in case you need to clean up any blobs.*

1. As always, the first thing you've got to do is prep. Pull out the shoestrings and set them aside, then carefully go over all the surfaces of each shoe with acetone or deglazer and cotton balls or a soft cloth. If you haven't done prep before, see the details on page 19.

2. Find a camo design you like online or in a magazine. Decide whether you want to cover the entire shoe with pattern or just add it in a few sections. On mine, I painted the toe box (the section on top of the toe area) and the swoosh on the side. Tape around the areas you'll be painting. I use 3M red vinyl tape; use what works for you.

3. Start by coloring in the background. Shake the pen well. Press down on the tip when you start to draw to make the paint flow. Maintain steady pressure on the tip as you paint the surface of the shoe.

4. When you've got the first coat of background color on, dry it with the heat gun or blow-dryer. (If it's easier, you can blow-dry one section of the shoe at a time, instead of waiting until the entire background color is down.) Oil paint requires more drying time than acrylic paint.

5. Using the same pen as before, color a second coat of paint and dry it with the blow-dryer. The background is done and you're ready to start the camo.

6. If you found a camo design you like online, don't worry about trying to copy it exactly—just use it for inspiration. Take the two darker blue pens and start drawing the squiggly bean and cloud shapes. Draw the outlines of the shapes first and then color them in. Put one color next to the other and let some of the background color show too. You'll put a second coat of paint on the camo spots, so don't worry if you can see through the color a little.

7. Blow-dry the first coat, and then repeat with a second coat of paint on the camo spots. Keep going until all the areas are done. Dry the painted areas with the blow-dryer again and you're done with the painting. Let the shoes sit to make sure the oil paint is completely dry. Remove any tape.

8. Get out the acrylic finisher, brush, and blow-dryer. When your shoes are thoroughly dry, give them two coats of finisher, using the blow-dryer or heat gun after each coat. You've got a new pair of shoes!

WHY NOT?
Practice on Paper First
Paint pens are easy to work with, except for one thing—if you press down too hard while you're working, the paint comes out in a big runny blob. You definitely don't want that to happen. So, get out that sketchbook or scrap paper, and do some practicing to get the feel for how much pressure to apply.

Paint pens contain oil paint. Between uses, the pigment in the paint can separate from the oil, so before using them you've got to give the pens a good up-and-down shake to make sure the color is blended and the paint comes down to the tip—ready to flow when you're ready to go.

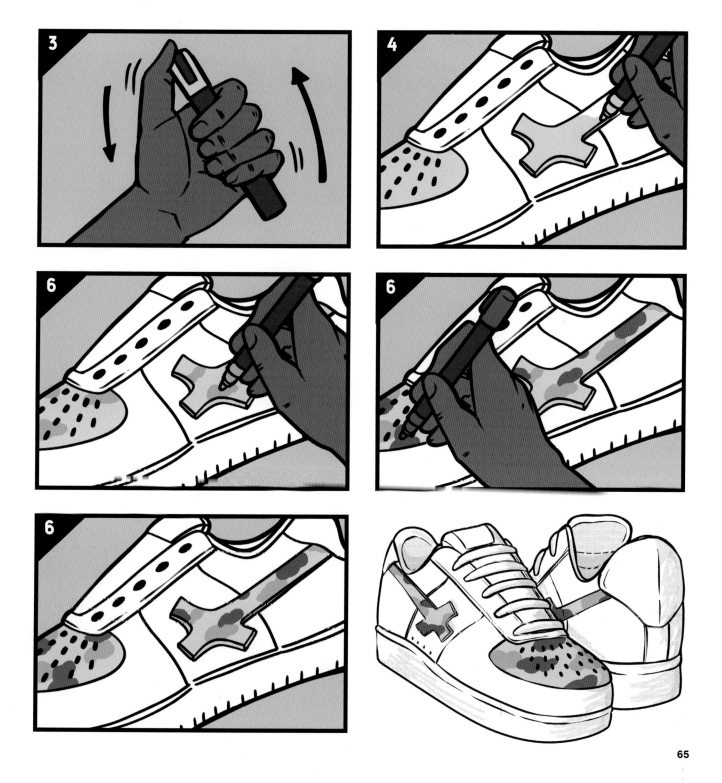

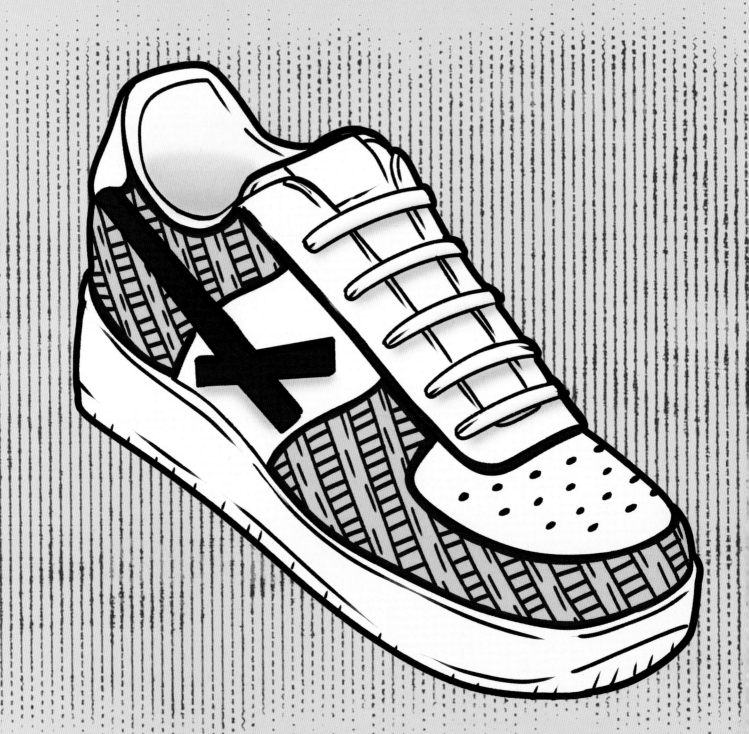

FINE-LINE QUICKIE

SCAN TO SEE A
TUTORIAL

Versatility—that's what's so great about working with paint pens. You can use them to create so many different kinds of colorful looks, and you don't need a big workspace or any special equipment—just pick up a pen and get to work, or just start doodling.

I did these shoes completely with two colors of pens. One thing to remember is that some brands are available with a wide range of nibs—from extra-fine (0.7 mm) to extra-wide (0.17mm) and from fine-point to chisel-point—that will allow you to draw everything from the smallest details to the broadest outlines and background color.

This custom has a look that reminds me a little of the "Cartoon Kicks," page 32. It's *so easy*, you can do it completely freehand. It's kind of a straight-line doodle—quick and fun to play with. Remember that paint pens are oil paint and take longer to dry than acrylic. Make sure your two coats of background color are *thoroughly* dry before you add the black linework, or the color will smear. Be careful about pressing down hard on the nib when you do the linework to prevent blobs.

You'll need:
- **Leather sneakers**
- **Acetone** or **deglazer**—for prep
- **Cotton balls** or **soft cloth**—for prep
- **Vinyl tape**—for protecting unpainted areas of the shoes
- **Scissors** or **craft knife**—for cutting the tape
- **Paint pens**—color for background, black for linework
- **Blow-dryer** or **heat gun**
- **Acrylic finisher**
- **Brush**—for applying finisher

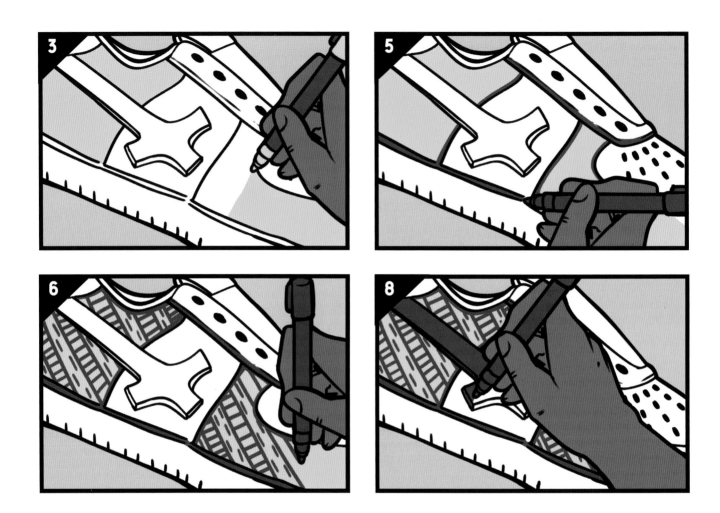

1. Take out the shoestrings and do your prep—clean the shoes using acetone or deglazer with a cotton ball or soft cloth. If you haven't done prep before, see page 19.

2. Tape the midsoles and any other areas you want to keep clean while you're working. I use 3M red vinyl tape; use what works for you.

3. Choose your paint pens and color the first coat in any areas of the shoe where you'd like to have a pop of color. Remember that paint pens are oil paint, which takes longer to dry than acrylic.

4. Use the blow-dryer or heat gun to dry the first coat of color. Apply a second coat and dry it.

5. When the background color is dry, use a black paint pen to outline the painted areas boldly.

6. Use the black paint pen to draw in the pattern of lines—my pattern looks a little like wooden floorboards. Be careful as you work to keep your hands away from the lines as you draw them—you'll smear the paint if you touch it before it's completely dry.

7. Dry the ink with the blow-dryer or heat gun.

8. Go back in with a black paint pen and color in the swoosh.

9. Remove the tape. Paint on two coats of an acrylic finisher, drying the coats with the blow-dryer or heat gun in between. That's a really sharp look for a custom sneaker that's so easy!

DYK?
I did this project completely with paint pens, but you could get the same look with Sharpie lines on a paint-pen background, or Sharpie on a painted acrylic background.

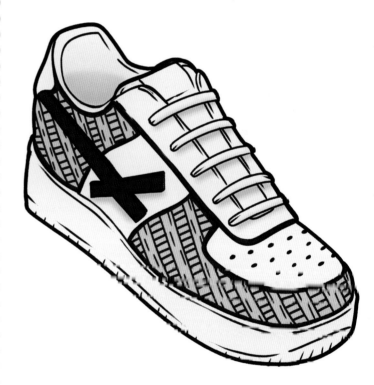

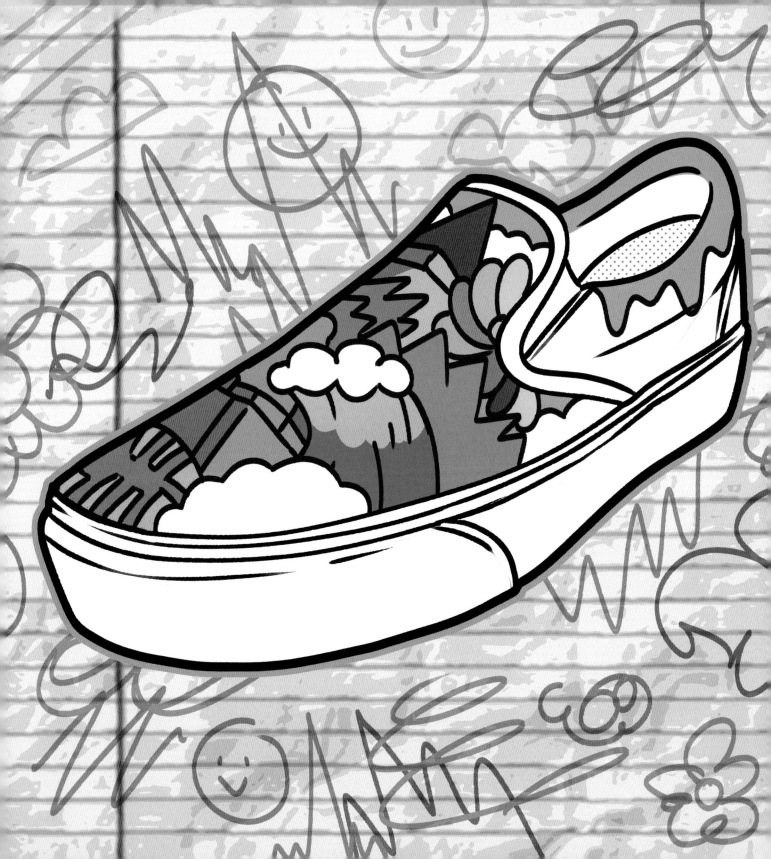

PAINT PEN DOODLING

SCAN TO SEE A
TUTORIAL

A slip-on sneaker is perfect for doodling because it gives you such a smooth surface to work on and you can change up your design as you go from the front to the sides and then around to the heel of your shoe. I recommend starting with pencil so you can make your mistakes before you commit to paint pen color. The paint in Posca pens are oil, so once it goes down on the white canvas, it's permanent—do your pencil sketch first!

In a custom like this, take advantage of the huge range of colors available with paint pens. I've made the colors pop by adding black outlines and the occasional black detail for dimension. Those outlines are clean—they make the shapes and colors jump.

Doodling is just pure fun—it's drawing whatever is hanging out in your imagination. It doesn't have to make sense. Have fun with it, but if you get stuck for ideas, look around at what others have done. I was inspired by the Belgian artist Vexx's doodles on YouTube. He does amazing videos. I picked up some ideas from him and then took them in my own direction. You can do that too.

You'll need:
- **Canvas slip-on sneakers**
- **Pencil** and **eraser**
- **Posca Markers**
- **Blow-dryer** or **heat gun**
- **Acrylic finisher**
- **Paintbrush** or **airbrush**—for applying finisher
- **Waterproofing spray** (optional)

1. Begin sketching the design on your shoes with a pencil, starting at the front, then moving around to the sides and heel of the shoe. I doodled cartoony towers and buildings and things on the front and heel, and flames on one side of the shoe and drips on the other.

2. When your sketch is done, get out your pens and start filling in the color. Be sure to leave some white areas for contrast. Don't forget that the ink in paint pens is oil and takes time to dry. With a project like this, I keep my heat gun at hand and use it each time I fill in a section with color—back and forth, pen to heat gun. That takes time, but remember, *you don't have to color in the entire design all in one session.* Do a little at a time, put the shoes aside, let the paint dry, and get back to your paint pens another time.

3. If two wet areas of color touch, they can bleed into one another and blend. Maybe that's a look you want, but if it's not, make sure that one painted area is dry before you put down another color right next to it.

4. Use the blow-dryer or heat gun to go over your shoes. Be sure all the areas of color are completely dry before adding the black outlines. You do not want the black lines to bleed into the color.

5. Choose a black pen with a fine tip and add the outlines to your drawing. Use a light touch—if you bear down on the pen too hard the lines may be thicker than you want.

6. Brush or airbrush on two coats of finisher, blow-drying each coat. For extra protection, add a coat of waterproofing spray.

7. Wow. Good color, right? I'm really happy with the way these turned out.

HEADS UP!
Let's Talk about Designing
One rule of thumb to keep in mind when you're sketching on shoes is to not make the design too tight and small. It will be easier to work with, and the finished design will have a lot more impact, if you keep the shapes fairly bold. You might open your sketchbook and test your design in paint pens on paper before trying it on your shoes.

Also, think about the different sections of your shoe. I used drips on the sides of my shoes because they fit the narrow shape and made a fun cartoony transition from the dense buildup of shapes on the front.

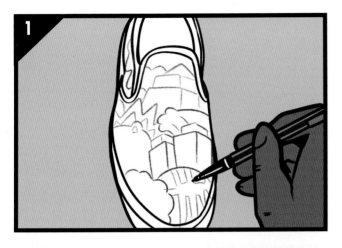

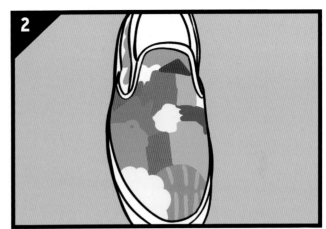

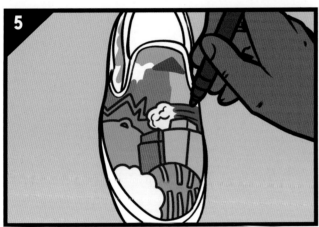

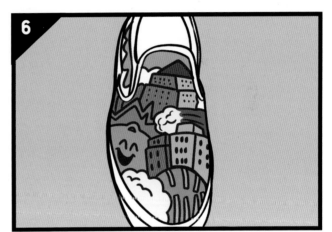

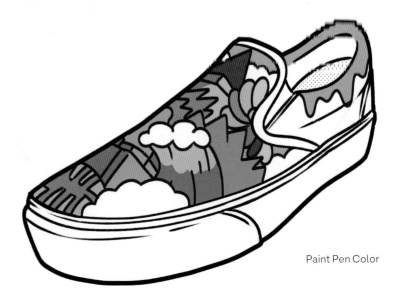

PAINT PEN ON DARK COLOR

SCAN TO SEE A
TUTORIAL

You might have wondered what happens if you use paint pen color on your kicks with a dark background. In the painting and airbrushing sections of this book we talk about how, in applying color to a black sneaker, you need to paint the background white first. Otherwise, the color will have a grayish tone. The same thing is true with paint pens.

I actually started this project with a pair of white canvas Converse high-tops, but I decided I wanted to do a freehand gaming design on black. First, I airbrushed the shoes, mixing black acrylic leather paint with GAC 900, to adapt the paint for fabric, and Angelus 2-Thin to make it the right consistency for airbrushing. When the paint was thoroughly dry, I drew my initial design on the black background using a white Posca pens. And when that was dry, I went over all of the white areas with colored Posca pens.

Adapt the process to whatever kind of dark-background design you have in mind. Maybe it's outer space, maybe it's undersea, maybe it's Halloween night. Give the color a couple coats of airbrushed finisher when you're done, and it will stay just the way you drew it.

You'll need:
- **Pair of canvas high-tops**
- **Vinyl tape**—for protecting unpainted areas of the shoes
- **Airbrush and compressor**
- **Black acrylic leather paint**
- **GAC 900**
- **Angelus 2-Thin**
- **Heat gun** and **blow-dryer**
- **Sketchbook** or **scrap paper**
- **Pencil**
- **Paint pens**—in white and assorted colors
- **Acrylic finisher**

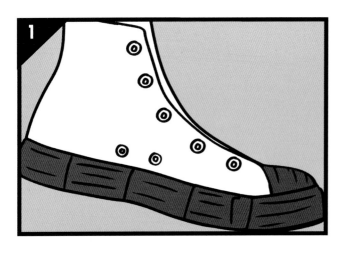
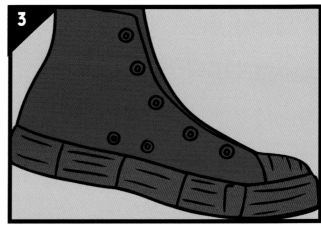

Note: Steps 1–4 are for painting white sneakers black. If you are starting out with black sneakers, skip to step 5.

1. You don't need to do the usual prep on this shoe because it's canvas. But since you'll be airbrushing, you do need to pull out those shoestrings and do your taping. Carefully tape the midsole, tongue, toe, logo, and back seam—any sections you want to remain white. I use 3M red vinyl tape; use what works for you.

2. Mix the black acrylic paint with GAC 900 at a 1:1 ratio. Then mix it with Angelus 2-Thin (see "Airbrushing Basics," page 104), so that the paint is the consistency of milk. Pour the black paint into the cup on the airbrush, set the compressor to 20 psi, and spray the shoes black in a *very* light coat—just the lightest coating. You're completely changing the color of the shoes, so you need to build the color in slow stages.

3. Dry the paint with the heat gun. Apply a second coat of black paint and dry it again. Keep going back and forth between painting and drying layers until you have a deep, even black. Clean the airbrush as detailed on page 107.

4. When the black background is thoroughly dry, remove the tape.

5. Work out your color design on scrap paper or in your sketchbook.

6. Use a pencil to draw the design on your shoes.

7. Go over your pencil lines with a fine-point white paint pen. Blow-dry the white pen lines.

8. Choose your paint-pen colors. Outline and then color in each part of your design, blow-drying the paint as you go along.

9. Repeat step 8 until the color is as vibrant as you want it.

10. When the paint is thoroughly dry, apply several coats of finisher with the airbrush, blow-drying after each coat.

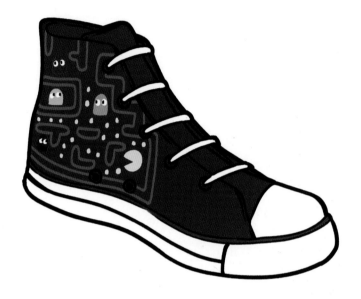

HEADS UP!
Let's Talk about Leather Paint on Canvas Shoes
You can use acrylic leather paints in all their colors on canvas sneakers, but you need to add a medium that will make the paint flexible enough for fabric. Do this by adding GAC 900 Acrylic Medium to your paint at a 1:1 ratio. To work properly, GAC 900 has to be heat-set—with a heat gun—for three to five minutes after the paint has been applied. If dried properly, the fabric will retain its softness. Be sure to open the windows when you use GAC 900. It contains formaldehyde and requires proper ventilation.

SNEAKERS
IN CULTURE AND COMMUNITY

SNEAKERS, SPORTS, AND GETTING THAT LOOK

It's worth saying again—"form follows function," and athletic shoes are certainly all about performance. But that doesn't mean they don't also represent the coolest, cleanest, most enviable look that everyone wants to wear. Every feature you love best about your kicks—the light weight, the cushioning, the bounce, the sleek design, and the flexibility—were originally built in to enhance athletic performance. The same companies that designed and created shoes worn by Olympic gold medalists and hoop stars back in the 1920s are the biggest pop-culture sneaker brands today—and in 1984, it was basketball that launched the beginning of custom.

1921

The game of basketball was invented by James Naismith in 1891, but it wouldn't be until 1921, when semi-pro basketballer Chuck Taylor began promoting a **Converse** sneaker that it became THE shoe to wear on the court. The Converse Rubber Shoe Company—manufacturer of galoshes—had been making a sneaker since 1908 and basketball "boots," called All Stars, since 1917, but Chuck Taylor significantly helped improve the design that became **Converse's Chuck Taylor All Stars**—or **"Chucks."** The iconic ankle patch was added in 1923, Taylor's signature was added to the shoe in 1932, and in 1936, **Chucks** were worn by the first U.S. Olympic basketball team.

1924

Elite British runners Harold Abrahams and Eric Liddell were silver and gold medalists respectively in the Paris Olympics wearing shoes by J. W. Foster, the co-founder of **Reebok**. Their story for glory was memorialized in the 1981 film *Chariots of Fire*.

1936

Track star Jesse Owens won four gold medals at the Berlin Olympics wearing track shoes by brothers Adi and Rudi Dassler. In the 1940s, Adi went on to create the **Adidas** company, giving his sneakers his name. Rudi created the **Puma** shoe company, naming his brand after the wildcat.

1968

Sprinter and gold medalist Tommie Smith became the first man to run 200 meters in less than 20 seconds at the Summer Olympics in Mexico City—he was wearing **Puma Suedes**. Smith and bronze medalist John Carlos created international Olympic controversy when they appeared shoeless at the awards ceremony and raised their fists to protest apartheid and Black poverty. They were expelled from the games at the time but are celebrated for their protest today. The **Puma Suede** went on to become a favorite of hip-hop artists and break dancers.

1984

Sneaker culture launched when **Nike** came out with the first custom **Air Jordans** designed by Peter Moore exclusively for Michael Jordan. Commercially produced custom Jordans were released to the public the next year, and soon after, hand-customizing by individual artisans began to take off. Every other major sneaker company began to compete, changing the way sneakers looked forever.

1949

The gum sole on the **Adidas Samba** was created for the shoe's use on icy terrain, allowing for agility and train and play in winter. In the 1970s, the shoe was remodeled for hard surfaces and futsal—indoor soccer—as well as for casual wear. The punk-rock group Bouncing Souls saluted the Samba in 1999 in their hit song "Ole."

1971

Chuck Taylor got his name on a _____ _____ _____ _____ to have a signature sneaker was Walt "Clyde" Frazier—the name behind the **Puma Clyde**. Frazier was also responsible for the look and style of the shoe and the trend for kicks in every color. Labeled "the essence of cool," his was the first flat basketball shoe, and he wanted it in suede and with a new color combination for every game he played—a total of 390 colors were used.

CRAZY

Color

Why settle for a jar of acrylic and a paintbrush when you can paint your shoes using shaving cream, a toothbrush, Rust-Oleum, or a plastic knife? Inventive custom techniques produce amazing color effects like marbelizing, tie-dye, drips, splatter, or galactic clouds and stars. Best of all, these techniques provide a pop of style and color without requiring special drawing or painting skills. In fact, hydro dipping, and shave-cream coloring are really fun outdoor activities for creative customizers at every level of experience and all age groups. Roll up your sleeves and get out the garden hose, because it's going to get messy!

SHAVING CREAM COLOR

SCAN TO SEE A
TUTORIAL

You read that right. We're going to do this custom with shaving cream colored with shoe dye! I thought it was insane when I saw this being done on TikTok by Jake Polino [@Jake Polino]. He'd seen videos about customizing canvas shoes using shaving cream and food coloring and wanted to try the same technique on a pair of Air Force 1s. So, he used leather dye with the shaving cream instead of food coloring. It works. I'll show you how to do it. Your kicks are going to have a very cool marbled look when you're done.

Shoe dye is a liquid. If you can't find it at your crafts store, you can usually buy it at a shoe repair shop. You'll also need a big plastic bin, at least 16" x 20" (40.6 x 50.8 cm) and 8" (20.3 cm) inches deep. It needs to be big enough to hold both shoes at the same time and still have enough space for the foam to come up and around the sides of the shoes. You'll want to do this outdoors: Its messy, shoe dye is not good stuff to breathe, and when you're done with the dyeing, you're going to rinse off the foam with a garden hose.

You'll need:
- **Leather sneakers**
- **Acetone** or **deglazer**—for prep
- **Cotton balls** or **soft cloth**—for prep
- **Vinyl tape**—for protecting unpainted areas of the shoes
- **Scissors**—for cutting the tape
- **Big plastic bin**
- **Shaving cream**—two cans, the foamier the better
- **Shoe dye**—at least two colors that work well together
- **Stick** or **paintbrush**—for mixing the dye into the foam
- **Rubber gloves**—optional, but shoe dye isn't easy to get off your skin
- **Old newspaper**—for the painted shoes to rest on
- **Garden hose**
- **Acrylic finisher**
- **Brushes**—for applying finisher
- **Heat gun**—for drying the finish

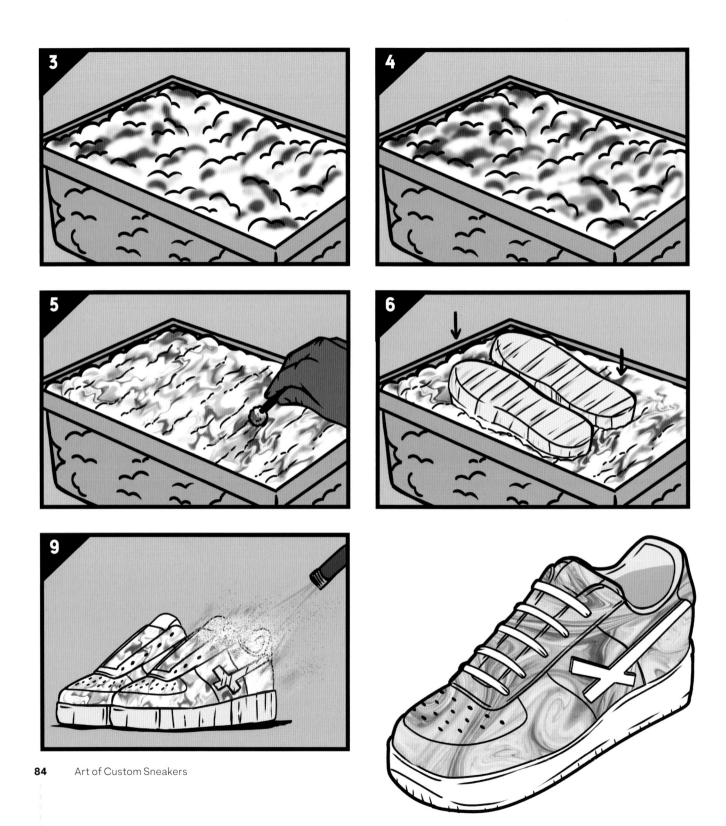

1. As always, start with your prep. Take those laces out, then clean the factory finish from the surface of your shoes completely. If you haven't done prep before, follow the directions on page 19.

2. Tape all the areas of your shoe you don't want the dye to touch. The dye will color the rubber soles of your shoes, as well as the leather, so if you want the soles and any other rubber parts of the shoe to stay clean, tape them. I use 3M red vinyl tape; use what works for you.

3. Now for the fun part. Place your plastic bin outside on the lawn. Grab a can of shaving cream and shake it up. Spray a nice thick layer of the foam inside the bin. Then do it again. Use the second can of shaving cream if you need to, until you have about a 6" (15.2 cm)-thickness of foam filling the bin.

4. Open the first bottle of dye and use the applicator attached to the lid to sprinkle and dribble the dye across the foam. Then do the same with the second dye color. Don't be stingy with the dye—you want it to show up on your finished shoes. I used red and blue the first time I tried it and got some nice purples in the mix. Red, yellow, and blue gave me a whole spectrum of colors.

5. Use a stick or an old paintbrush to swirl and marbleize the colors into the foam. Add a little more color if needed. Don't mix the dye in too much or you'll get a solid color: You want the colors to streak and swirl and do fun marbly things on the foam.

6. Pull on your gloves and pick up a shoe in each hand, holding them by the soles. Hold them above the bin, sole side up, and push them both down into the foam at the same time. You want the colored foam to come up between the shoes and to cover the outer sides completely as well.

7. Let them sit in the foam for a minute. Don't move them.

8. Lift the shoes out of the foam and set them on some old newspaper.

9. Get out your garden hose and gently spray away the foam. The look will be something in between marbled and tie-dyed. You don't know what you're going to get until the foam is gone. The color's dope!

10. Let your shoes dry completely. That may take a full day.

11. Don't forget your finish! When your shoes are completely dry, get out your acrylic finisher, brush, and heat gun and give them two coats of finish, using the heat gun to dry after each coat.

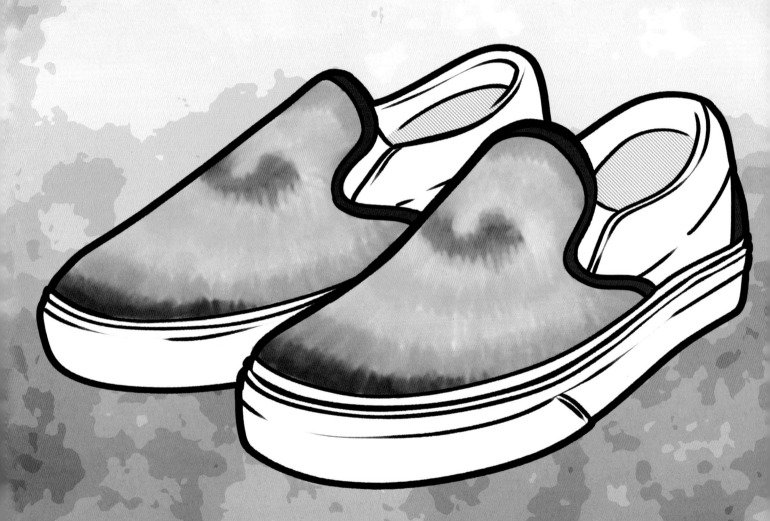

SHARPIE TIE-DYE

SCAN TO SEE A
TUTORIAL

I know there are a lot of tie-dye fans out there because my sister's one of them. This is a custom you can have fun with—no painting required. Instead, you'll be coloring directly on canvas sneakers with permanent markers like Sharpies, and you can use any kind of white canvas sneakers. Slip-ons like Vans are especially good for this technique because they give you a wide, smooth, uninterrupted surface.

The tie-dye effect works because you sprinkle rubbing alcohol on top of your Sharpie color, which causes the ink to blur. You might have rubbing alcohol in your bathroom cupboard. It's used as a disinfectant, but it's also a solvent, and Sharpie ink happens to be one of the things it dissolves. You want to sprinkle or spritz the alcohol on the ink *very lightly* to get the blurred color. If you use too much, it could cause the ink on your shoes to run and leave drip marks.

You can buy permanent markers in sets of twelve or twenty-four in different colorways—like neon or color burst. Whether you buy yours as a set or individually, choose light, bright colors for this custom, so the color stays bright when it blurs.

You'll need:
- **Canvas sneakers**
- **Vinyl tape**—for protecting unpainted areas of the shoes
- **Scissors**—to trim the tape
- **Sharpies**—at least six bright colors
- **Rubbing alcohol**
- **Medicine dropper** or **spray bottle**—for applying the alcohol

1. Open the windows. Sharpies are great but—you know—that smell. Sharpie ink contains solvents that become gases at room temperature. You don't want to breathe that. It can give you a headache. Make sure you have good ventilation.

2. There's no prep for the canvas, but if you haven't done this before, protect the midsoles of your shoes by covering them with tape so you don't accidently get Sharpie marks on that clean white rubber. I use 3M red vinyl tape; use what works for you.

3. I started drawing my spiral right at the front of the shoe, beginning at the center of the spiral and working outward, round and round.

4. I more or less followed the regular color order of the rainbow, but I used light, bright transparent versions of each color. You don't want to use a heavy green or blue or purple, because they won't blend well with the colors they're next to. You want the colors to stay bright when they blend. So, I've got red in the very center of my spiral and then orange, yellow, light green, light blue, pink, and bright purple.

5. Make each band of color about ¾" (.96 cm) wide, just coloring back and forth to fill it in. Don't worry if you have some skips in your color, where you can see the white canvas: When you sprinkle the rubbing alcohol on it, all of that will fill in. All of your drawing lines will fill in too, so don't worry if you don't think yours looks perfect.

6. If you didn't protect your midsoles with tape, be careful with your Sharpie as you get close to the rubber. When you've covered as much of the canvas as you want with color, you're ready to blend.

7. Fill a medicine dropper or a small spray bottle with rubbing alcohol, and lightly sprinkle or spritz it over the colored surface of your shoes. You want to be sure to get a little bit of the alcohol along all the lines where two colors meet so they blend together. Just a light spritz is all you need—it's magic.

8. Set the shoes aside and let them dry completely. Remove any tape. They look good, tie-dye fans! I'm giving mine to my sister!

DYK?

When you doodle with Sharpies on canvas sneakers, there's a chance the ink will bleed into the canvas a little, which makes your lines look fuzzy. You can stop that from happening by giving the canvas a light coat of white paint first, letting it dry, and then drawing with Sharpies on the prepared surface.

But for this tie-dye project, fuzzy lines are exactly what you want, so there's no prep necessary. Just draw with the Sharpies directly onto the canvas. I did a tie-dye rainbow-spiral on my Vans, but this kind of blurred color could work pretty well if you wanted to draw something like a sunset with yellows and oranges and a little purple and pink in there too. Be creative.

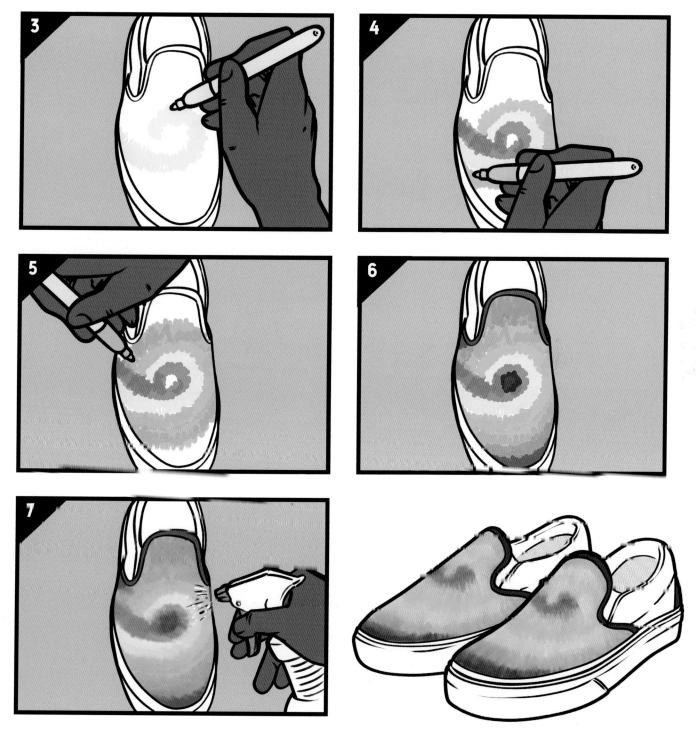

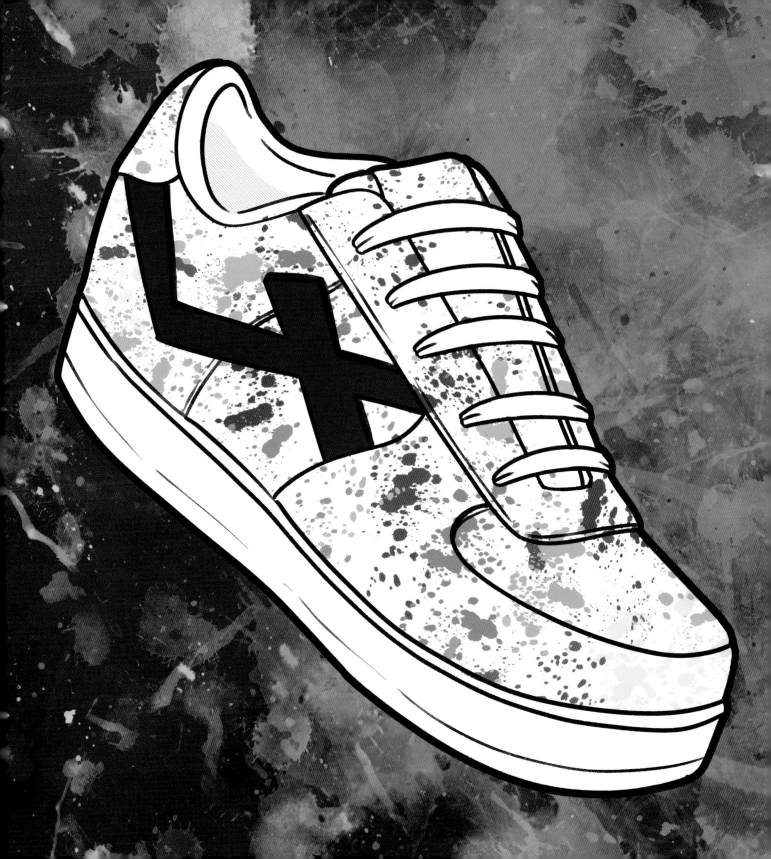

COOL COLOR DRIP

SCAN TO SEE A
TUTORIAL

Feel like loosening up your style? Ready to put down that airbrush and try something completely different? How about painting with a plastic knife? Crazy, right? That's what I did with this custom and I think it's so cool. I painted the black swoosh with a brush to make the whole look pop, but the rest of the shoe is painted entirely with neon-colored leather paints and plastic knives.

You don't have to be an expert painter for this, but there are still a few things to know before you start. For one thing, it gets really messy—when you flick paint at the shoe, it gets all over everything. Put down some newspaper, and cover everything around your painting area. When I did it, I opened the top and one side of a cardboard box and put one of the shoes inside. I painted one side of the shoe, then turned it around and painted the other side. The paint splatters stayed inside the box.

Another important thing is to keep your heat gun or blow-dryer handy. If you drip and splatter too many colors without drying them in between, you'll get mud. Keep drying as you go.

You'll need:
- **Leather sneakers**
- **Acetone** or **deglazer**—for prep
- **Cotton balls** or **soft cloth**—for prep
- **Vinyl tape**—for protecting unpainted areas of the shoes
- **Scissors** or **craft knife**—for cutting the tape
- **Newspapers**—for covering your work surface
- **Cardboard box**—(optional) for containing the paint flicks
- **Acrylic leather paints**—I used six neon colors
- **Plastic knives**—one for each color
- **Heat gun** or **blow-dryer**
- **Black paint**—(optional) for the swoosh
- **Paintbrush**—(optional) for the swoosh
- **Acrylic finisher**
- **Paintbrush for finisher**

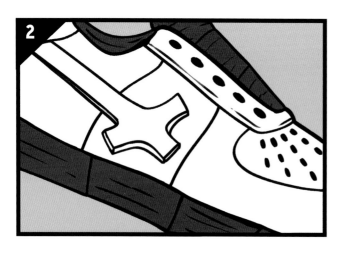

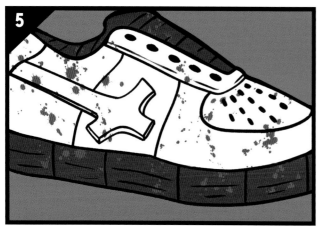

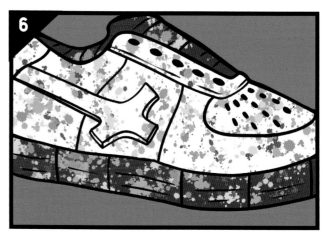

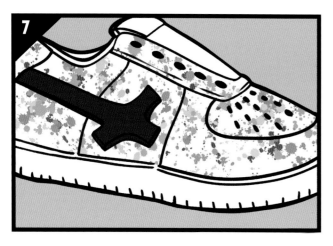

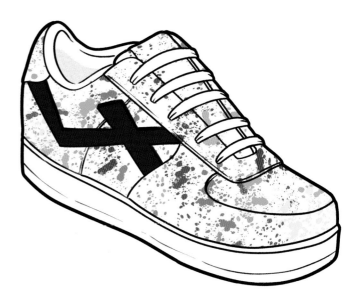

1. The painting technique may be different on this custom, but the prep is the same as on other shoes. Get those shoestrings out and clean the entire leather surface with acetone or deglazer and cotton balls or a soft cloth.

2. Tape the midsoles of the shoes and the sock liner, and cover the entire opening of each shoe so that paint cannot get inside. I use 3M red vinyl tape; use what works for you.

3. Cover your work surface with newspaper, or open the side of a cardboard box and place your shoe inside.

4. You're ready to paint. I chose neon colors for my shoes because it's such a crazy look and the neon really brings that out. Open the first color and dip in your knife.

5. When you've gotten your wrist technique down, flick the first color of paint on your shoe. Be free with it—do what you want. Then dry the color with the blow-dryer or heat gun.

6. Choose your next color and repeat step 5 for it and all the remaining colors. If you're painting your shoe inside a box, paint and dry all of the colors on one side of the shoe first, then turn the shoe around and repeat the process.

7. When you are happy with your splatter and the paint is thoroughly dry, paint the swoosh with black paint and a brush, if you wish, and dry it with the heat gun.

8. Give the shoes two coats of acrylic finisher, drying after each coat.

9. Put those shoestrings back in and show the world what you've created.

HANG ON A MINUTE

It's all in how you flick your wrist. Practice flicking the paint at something you can discard before you try it on your shoes—you need to get the hang of it first. You might try a quick left-to-right flick, or an even quicker overhand flick.

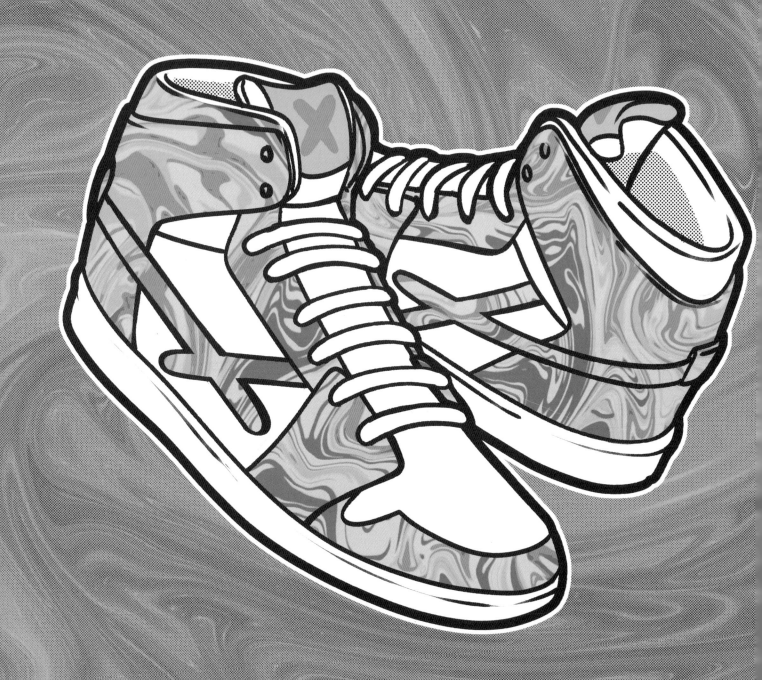

HYDRO-DIPPED MARBELIZING

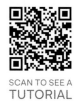

SCAN TO SEE A
TUTORIAL

You have to wonder who comes up with ideas like spraying Rust-Oleum into a tub of water and dipping their shoes into it to see what happens. That's what you do with hydro dipping, and what happens is the most beautiful custom marbelizing you can imagine. It's magic. Or, maybe not quite magic, but very colorful proof of an old principle we're all familiar with: Oil and water don't mix.

Rust-Oleum is oil paint in a spray can. It dries with a very durable finish that has enough stretch to it that it works well on shoes. Because it's oil-based, when you fill a big tub full of water and spray Rust-Oleum on the water, it floats on top.

That part of this custom is science—the creative part is up to you, and that is where you're going to have fun with this project. Choose at least two colors—one dark, one light—that will work well together, like orange and yellow, or purple and blue. The colors will swirl around each other but will also blend into new colors. It's best not to use more than three colors because they could become muddy when they blend.

You'll need:
- **Leather sneakers**
- **Vinyl tape**—for protecting unpainted areas of the shoes
- **Snap-blade knife** or **craft knife**—for cutting the tape
- **Plastic bags** or **bubble wrap**—for protecting the shoe opening
- **Acetone** or **deglazer**—for prep
- **Cotton balls** or **soft cloth**—for prep
- **Plastic storage tub**—16 gallon (or 66 quart) size
- **Access to outdoor water hose**
- **Rubber gloves**
- **Rust-Oleum white primer spray paint**
- **Newspapers**—to dry the shoes on
- **Rust-Oleum gloss protective enamel**—at least two colors: one light, one dark
- **Acetone and rags**—for cleanup
- **Acrylic finisher**
- **Paintbrush** or **airbrush**—for applying the finisher
- **Blow-dryer** or **heat gun**

HANG ON A MINUTE

When you spray the first color onto the water in the tub, the paint holds together like a floating island on the surface. Then, when you spray the second color right in the center of the first, it makes circles within circles of paint color. Spray both colors at once, spray outside of the "island," and watch the colors shade it like lava flow, like bursts of lightning, or like molten marble. You'll know when the marbled pattern is just the way you want it.

This could get messy! You'll want to do this outdoors, near a garden hose. And wear old clothes you won't mind getting wet or paint-spattered.

1. The prep for this project is a little different than usual. Pull out the shoestrings and set them aside. Very carefully tape the midsole, the eyelets, the padding around the ankle, or any other sections of the shoe you want to remain white. I use 3M red vinyl tape; use what works for you. Reread the section on taping on page 22 for reference. It's important to seal the edges around all the taped areas really well. These shoes are going to be submerged in water and paint, and you don't want the color seeping under the tape and ruining the clean line between marbled and white sections. Don't be stingy with the tape. Trim the loose edges carefully with a knife. Stuff crumpled plastic bags or bubble wrap into the shoe's opening so water doesn't get inside.

2. Clean the remaining areas with acetone or deglazer and cotton balls or soft cloths to remove the factory finish.

3. Use the garden hose to fill the plastic tub to within 3" to 4" (7.6 to 10 cm) of the top.

4. Pull on the rubber gloves, give the can of white Rust-Oleum primer paint a good shake, and spray the shoes with a light coat of primer. (The primer is meant for the exposed leather parts of the shoes, but it's fine if it covers the tape too.)

5. Carefully set the shoes on newspaper to dry.

6. Give your first color of Rust-Oleum a good shake-up and spray it onto the surface of the water in the tub. It will pool on the surface like an island of color.

7. Shake the second color of Rust-Oleum and spray it in the center of the first color. The marbling will begin.

8. With a can of Rust-Oleum in each hand, spray inside and outside the "island" of paint and watch the marbling and lava flow continue. (Resist the temptation to stir the marbling with a dowel or anything else. The paint will stick to the dowel and come up with it when you pull it out of the water. Let the paint and water create the magic by themselves.)

9. When the paint patterns are just right, pick up one shoe, hold it carefully by the midsole, turn it upside down, and dunk it straight down through the paint and into the clear water below it.

10. Pull the shoe out again and turn it upright. (You will have to clear away the loose paint on the surface of the water after you bring the shoe up through it.) The shoe will be completely covered with marbled paint—the taped areas too. Carefully set the shoe aside on newspaper to dry in a place where it can sit for at least twenty-four hours. Resist the temptation to touch the shoes while they're drying.

11. Repeat steps 6–10 for the second shoe. Set it aside to dry.

12. While the shoes are drying, clean up the tub and any other paint-spattered materials with acetone and rags.

13. When the shoes are thoroughly dry, pull off the tape. Removing the tape will also remove any excess paint.

14. Brush or airbrush two coats of finisher on the shoes, drying each coat with a blow-dryer or heat gun.

15. Magic, right? These shoes really look amazing.

GALACTIC SPLATTER

SCAN TO SEE A
TUTORIAL

This custom takes its cue from our own beautiful galaxy—the Milky Way—but the "stars" in this galaxy are created by splatter painting with a toothbrush and white paint. The stars make a great contrast on top of the airbrushed clouds of cosmic color. Look on the internet for photos of the night sky for inspiration.

The trick is to leave enough black background showing through to make it feel like a night sky, but add just enough pink and violet and light blue to create the crazy light around the stars and the look of deep space. The hazy look kind of happens by itself as you're airbrushing, but think about the balance of colors.

Only the most basic airbrushing skills are needed for this project, but if you haven't airbrushed before, take a look at "Airbrushing Basics," page 104, to get you started. To create the base for the night sky, start with a pair of black canvas sneakers. I'm using Galaxy Vans, which are black canvas with white stitching. In step 1, I'll paint all the white stitching black for a consistent look. If the sneakers you're using don't have white stitching, just skip step 1.

You'll need:
- **Black canvas sneakers**
- **Acrylic paints**—flat black, light blue, violet, pink, black (optional) for touch-ups
- **Paintbrush**—small detail brush
- **Blow-dryer** or **heat gun**
- **Vinyl tape**—for protecting unpainted areas of the shoes
- **Craft knife**—to trim the tape
- **Acrylic paint thinner**—such as Angelus 2-Thin or GAC 900
- **Airbrush and compressor**
- **Rubber gloves**
- **Toothbrush**
- **Acrylic finisher**
- **Paintbrush for finisher**
- **Acrylic waterproofing spray**

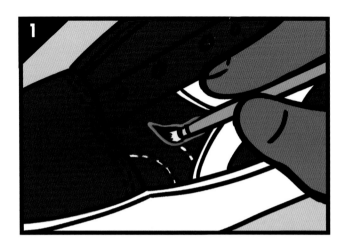

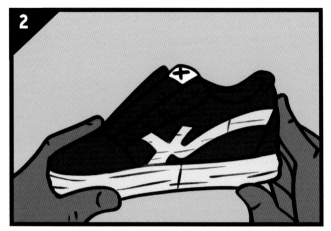

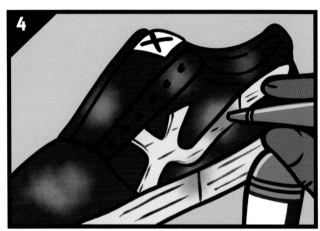

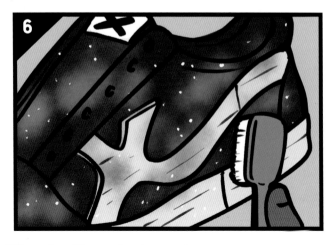

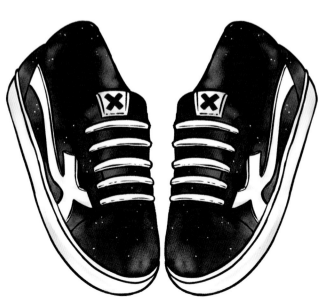

1. Using the detail brush and flat black paint, paint the white stitching on all the black areas of your sneakers. (Leave the white stitching on the white areas.) Use the blow-dryer or heat gun to dry the paint.

2. Tape the sneakers' midsoles, white side stripes, and tongues to protect them during airbrushing. I use 3M red vinyl tape.

3. Thin each color of paint with Angelus 2-Thin or another acrylic paint thinner to the consistency of milk before use in the airbrush.

4. Pour a small amount of light-blue paint into the airbrush cup. Lightly spray the sneakers—very faintly in some areas, a little more densely in others. You *do not* want an even coat of paint—it should vary and be very light, allowing the black background to show through. Dry the paint with the heat gun or blow-dryer.

5. Clean the airbrush by pouring some paint thinner—rubbing alcohol or a product like Angelus 2-Thin—into the cup of the airbrush and spraying it out again. When it's clean, pour a little violet paint—thinned to the right consistency with GAC 900 or Angelus 2-Thin—into the cup and repeat step 4, allowing the violet to overlap and blend with the light blue.

6. When the violet paint has dried, dip the toothbrush in white paint and splatter your shoes, allowing for some denser groupings and larger star clusters.

7. Wait until the stars are thoroughly dry and then assess your galaxy. If it needs brightness, airbrush in some areas of pinkish highlight the purple and blue. If you covered up too much of the black background, airbrush in a tiny bit of black, to make your galaxy pop.

8. Paint or airbrush on two coats of an acrylic finisher, drying with the blow-dryer or heat gun after each coat.

9. Spray on a coat of acrylic waterproofing.

10. Remove the tape and put the laces back in.

WHY NOT?
Perfect Your Splatter

Get out that sketchbook or scrap paper and give yourself a practice session splattering paint with a toothbrush. It's fun and easy, but you'll want to know how to control the paint before you aim it at your shoes. There are different ways to splatter after you load the toothbrush with paint. You can simply shake the brush in the direction you want. You can tap the handle of the toothbrush with a larger paintbrush. The way I do it is to pull on some rubber gloves, dip the toothbrush bristles in white paint, and then pull back on the bristles with my thumb. Do this at a distance of about 2 feet (0.6 meters) from your shoes.

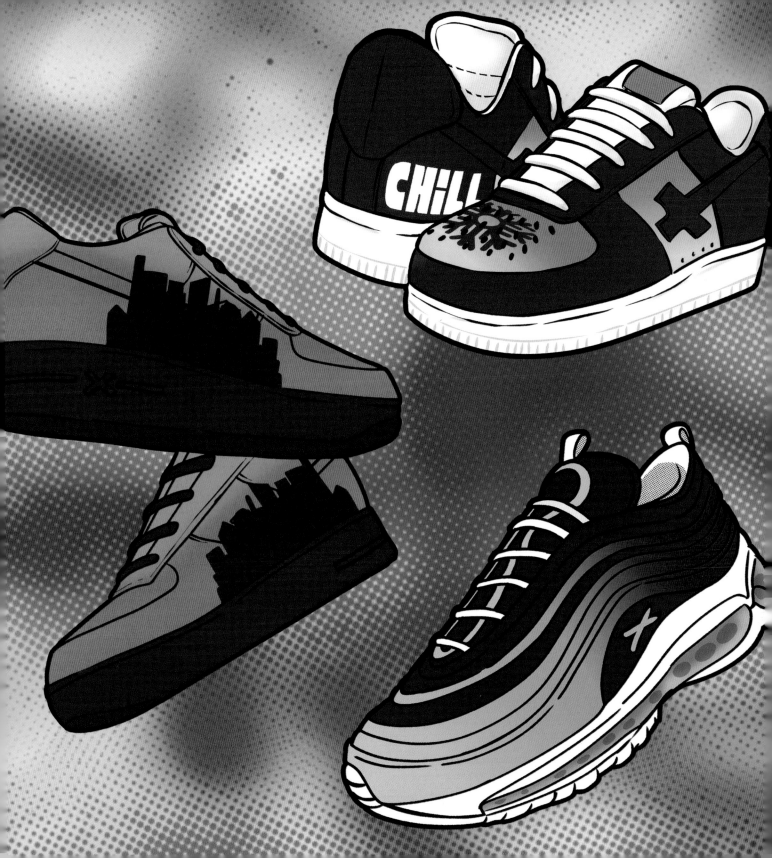

AIRBRUSH and STENCIL

More than any other customizing techniques, airbrushing creates "the look" for kicks. The cool fade and gradation of color allows you to capture everything from the distinctive vibrancy of a favorite team's jersey to the gorgeous tones of fantasy sunsets. Combined with stencils you can make yourself or purchase, airbrushing lets you aim for a totally professional look—quickly. Airbrushing requires special equipment, but it will last you a very long time. This chapter will get you started with everything you need to know.

AIRBRUSHING BASICS

This is where painting gets cool. Experiment with your airbrush, practice on paper, then start having fun with it.

If you're new to customizing, maybe you're new to airbrushing too. Like spray painting with a can of paint—airbrushing gives you a range of very cool finish options that you can't get with a paintbrush. Gradient color, for instance—the soft transition between different colors—is used a lot in customizing. I know you've seen that effect and you've been wondering how to do it yourself.

Airbrushing your shoes is a lot faster than brush painting, and it gives you a lot more control than spray painting with a can of paint, but it also requires some special equipment and learning how to use it. So, let's talk about the equipment first.

EQUIPMENT

You'll need (1) the **airbrush** itself, (2) an **air hose** that screws onto the stem of the airbrush, and (3) a small electric **compressor** that pumps air through the hose and pushes the paint out through a needle in the airbrush's nozzle. And, of course, you'll need (4) **paint**. You'll use the same acrylic leather paint you use for painting with a brush, but it needs to be thinned.

Airbrushes

Airbrushes can cost anywhere from around $80 to more than $600. They all do more or less the same thing. Most of the higher-end airbrushes have dual-action triggers, which allow you push down and pull back on the trigger so you can control the airflow and paint flow separately, or they have larger reservoirs for paint. *But here's the thing*: A good-quality airbrush in the lower price range will let you create all the special finishes you like and will last you a long time if you take care to clean it each time you use it. So, start with an affordable airbrush and practice with it until you really get to know it well and can create all the effects you have in your head.

Air Hoses

A lot of starter airbrushes come in a boxed set that includes the air hose and maybe several different needles. If you buy a hose separately from the brush—for instance, if you need a longer one than comes in the boxed set—make sure you buy one that has the correct screw-on connections for the airbrush and compressor.

Compressors

Compressors too can range in price from about $100 to many hundreds of dollars. You don't need a massive compressor for airbrushing your shoes. Some airbrush sets are sold complete with small compressors. Read up about the different options to find one that matches your needs.

Paint

When you pour paint into the cup on top of the airbrush, it should be about the consistency of milk. When you open a jar of acrylic leather paint for the first time, it's about the right consistency for an airbrush. But if the jar has been open for a while, the paint is probably too thick and needs to be thinned. The same manufacturers who make your paints also make thinner for the paints. Other acrylic thinners are available too, some labeled as high-flow mediums.* Put the paint and thinner in a small jar and shake it up. It's better to have it be a little too thin than a little too thick. Your airbrush will clog if the paint is too thick. If it's a little on the thin side, you can always apply a second coat. If the paint has any lumps in it, put it through a fine sieve before you put it in the airbrush cup.

If you're going to paint with acrylic leather paint on canvas sneakers, mix the paint with GAC 900 or Angelus 2-Thin at a 1:1 ratio.

GET STARTED

Attach the air hose to the airbrush and the compressor. Set the compressor to 20 psi. Pour a little paint into the cup on top of the airbrush and close the lid. Turn on the compressor. Hold the airbrush in your hand and press down on the trigger. Here it comes!

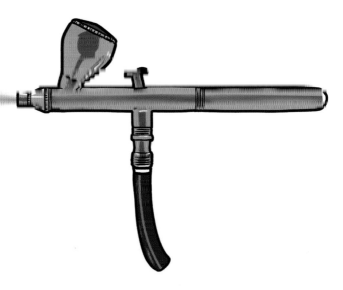

TECHNIQUES
Don't Skip This Step!

Airbrushing is a lot of fun; you'll have a good time with it. First, though, you've got to get used to what it feels like in your hand and how to control the flow of paint to get the effect you're looking for, instead of getting paint all over the room.

I know I've told you in many projects to get out your sketchbook or scrap paper and practice a technique before you try it on your shoes, but with an airbrush, *you really have to do that*. Practice until you're completely comfortable with it.

Practice making circles and straight lines. Draw some shapes on the paper with pencil and see if you can follow them with the flow of paint coming from your airbrush.

The farther away from your target you are, the more diffuse and misty the color will be. The closer to your target you are, the easier it will be to draw lines with your airbrush.

Single-Color Gradation

Try gradating with a single color first. Spray a very light coat of paint over a wide area. Then go back over it, but this time only coating three-quarters of the area. And continue, each time covering less and less of the original swath of paint

Two-Color Gradation

If you want to gradate with two colors, there are a couple of ways you can. Start with one color loaded in the cup of your airbrush. Spray that color first. Then add a second color to the cup so that you'll spray two colors at once. Then clean the cup and load it with just the second color to finish.

Another way is to spray on the first color, then clean out the cup and load it with the second color. Continue as you did with the single-color gradation technique. Lightly overlap the two colors first, then gradually move away from the first color as you add more coats of the second color.

CLEAN YOUR AIRBRUSH

You definitely don't want to gum up your airbrush with dried paint—it's a big pain to clean it if the paint dries. Make it easy on yourself and clean it each time you use it. You'll want to have solvents like rubbing alcohol, Angelus 2-Thin, and acetone on hand, as well as small cleaning tools, like pipe cleaners or interdental (dental) brushes for getting all the paint out of tight spaces.

For regular cleaning to remove wet paint when changing colors, pour a little rubbing alcohol or Angelus 2-Thin into the airbrush's cup and spray it through

Every airbrush manufacturer will have slightly different instructions for taking the airbrush apart, cleaning the individual pieces, and putting it back together again. Follow their instructions.

AIRBRUSHING BLACK LEATHER

SCAN TO SEE A
TUTORIAL

I love this custom—it looks like my Air Force 1s are melting, and the green melted "drips" make great use of the black sole of the shoe. We're going to talk about a couple of different things with this project. I'm sure some of you have wondered whether painting on black shoes is the same as painting on white leather—and that's one thing we'll cover. But this project also uses basic airbrushing techniques and combines them with brush painting. It's a great custom to start with if you're new to working with an airbrush but want your kicks to really say who you are—very satisfying.

As a matter of fact, airbrushing is probably the best kind of painting to use on dark-colored sneakers when you want to completely change the color, because the paint goes on so thinly with each coat. When you're painting with a brush on white sneakers, you usually do two coats. When you're changing the color of black sneakers, you have to add a primer coat—painting the shoes white first, and then applying several coats of your finish color. The thinness of airbrushed layers lets you do that.

You'll need:
- **Black leather sneakers**
- **Acetone** or **deglazer**—for prep
- **Cotton balls** or **soft cloth**—for prep
- **Vinyl tape**—for protecting unpainted areas of the shoes
- **Craft knife** or **scissors**—for cutting tape
- **Airbrush** and **compressor**
- **Acrylic paint thinner**—such as Angelus 2-Thin
- **Acrylic leather paints**—white for primer, neon popsicle green, black
- **Rubbing alcohol**—for cleaning the airbrush between colors
- **Blow-dryer** or **heat gun**
- **Paintbrushes**—one for black paint, one for green paint
- **Pencil**
- **Detail brush for white paint**
- **Acrylic finisher**
- **Brush**—for applying finisher

HEAD'S UP!
Let's Talk about Taping

We talked about the importance of taping earlier—see page ??—but with airbrushing and spray painting it's especially important. When paint comes out of an airbrush it diffuses and spreads beyond the spot you're aiming for. That's a good thing when you're gradating color, but not so good if you want sharp lines between different color areas on your shoes. If you want crisp lines—like between the upper part of the shoe and the midsole, for instance—do your taping!

1. Start with your prep. Take out those shoestrings and set them aside. Clean every surface of the shoes with the acetone or deglazer and cotton balls or a soft cloth. When you're working with black shoes, you'll see a little bit of the color come off on the cotton ball as you do this. If you *haven't* done prep before, follow the directions on page 19.

2. Taping is next. Tape every surface of the shoe that you don't want the paint to touch. For my shoes, I'm masking off the rubber midsole and the tongue. I'm not going to worry about taping the sock guard around the ankle because I'm going to paint it black later. I use 3M red vinyl tape; use the tape that works for you.

3. Make sure you've read the instructions that come with your airbrush and compressor and have practiced with them. Thin a small amount of white paint to the consistency of milk, using Angelus 2-Thin or another acrylic paint thinner. Pour a little thinned white paint into the cup of the airbrush and give your shoes a base coat of white. If you try to paint your final color directly on the black leather, the color will have a grayish tone—it won't pop. So, think of the white as a primer coat. The color will be a whitish-gray when you're done. It doesn't have to be stark white. The thin coat of white will dry quickly, but you can use your blow-dryer or heat gun to speed up the drying even more.

4. Clean the airbrush by pouring some rubbing alcohol or acrylic paint thinner into the cup and spraying it through. Be sure you aim it away from your shoes.

5. Thin a small amount of neon popsicle green to the consistency of milk, using Angelus 2-Thin or another acrylic paint thinner. Pour a little of the thinned green paint into the airbrush's cup. Airbrush a light coat of the green over all the untaped surfaces of your shoe. Blow-dry the paint. Apply and dry another coat until you have complete, smooth coverage.

6. When the green paint is thoroughly dry, remove the tape from the midsole and tongue. Now go back in with black paint and a brush and carefully paint the swoosh, the facing around the eyelets, the top of the toe box, the sock guard, and the heel. Give those areas a second coat of black paint, drying each coat with the blow-dryer or heat gun.

7. Grab your pencil and sketch a melting drip line along the bottom edge of the swoosh, the toe box, and the eyelets. Paint in the drip line carefully in black. Blow-dry and add a second coat.

8. Add a few green "drips" on the midsole. Dry and add a second coat.

9. When all the "drips" are thoroughly dry, use white paint and a tiny detail brush to add a few highlights that will give the drips a 3D look.

10. Use the tiny detail brush to color in the shoe logo on the midsole.

11. Now on to the finish. Get out the acrylic finisher, brush, and heat gun. When your shoes are completely dry, give them two coats of finish, using the heat gun to dry the finisher with each coat. If you prefer, you can apply the two coats of finisher with your airbrush instead.

HANG ON A MINUTE
I know you're wondering why I didn't just tape all those areas first rather than paint them black in this step. You can do it that way, of course, but when I was figuring out how to approach this project, it seemed quicker and easier to paint those areas black after the green, especially because we are about to add the fun part—the melting drips of color.

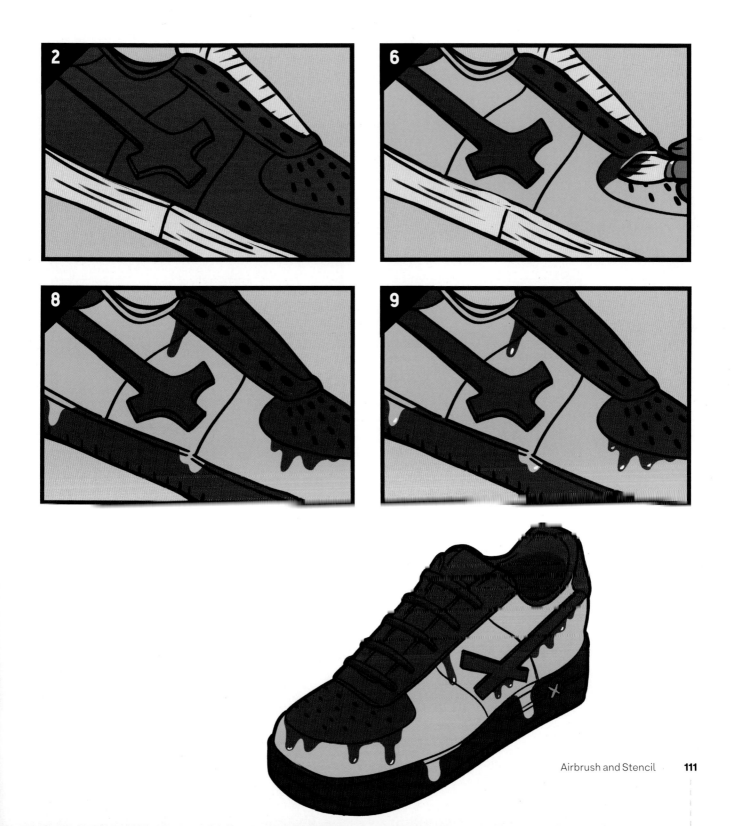

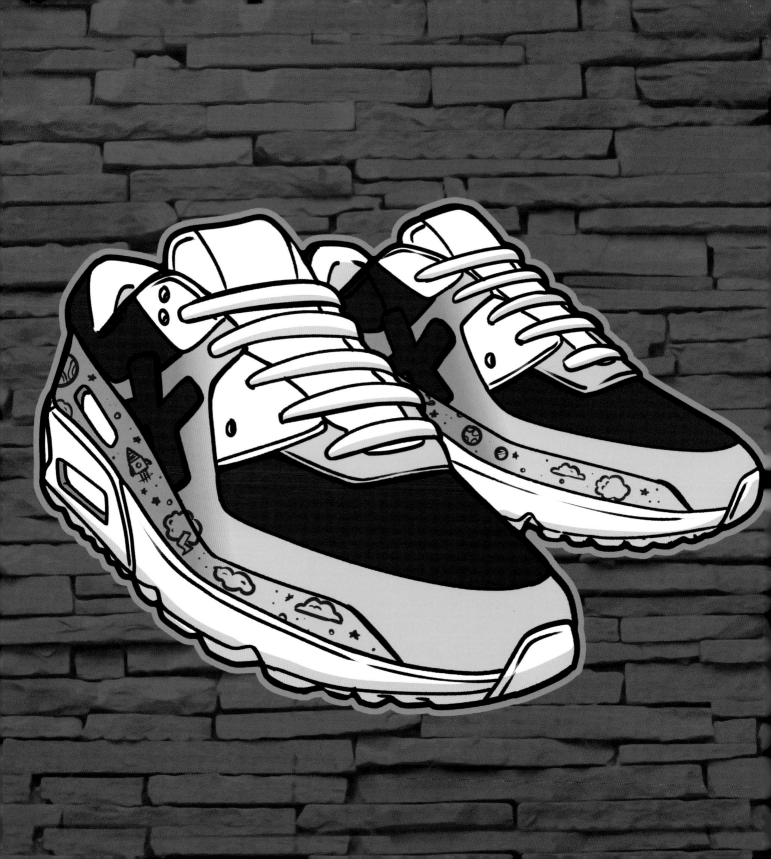

MIX IT UP

SCAN TO SEE A
TUTORIAL

With a lot of custom projects, you can get the same kind of look several different ways—for background color, for instance, you can use brush painting, airbrushing, or paint pens. For the details, you can chose from paint pens, Sharpies, or working with a detail brush or toothpick. Mix it up. This project is a good one for brainstorming what techniques you want to use, depending on what materials and tools you have on hand and what kind of painting you like to do.

These Air Max sneakers are fun to work on because the surface is divided into so many sections that can be painted different colors or used for featuring whatever details you want to add. I painted the turquoise and lilac sections of the shoe with an airbrush. I could just as easily have painted them with a brush or with paint pens, but in this case I wanted to work on a simple gradation where the two colors meet. That is an effect you can only get with airbrushing. I painted the black areas of the shoe with a brush and also did my outer space doodling with a tiny detail brush and black paint.

You'll need:
- **White leather sneakers**
- **Acetone** or **deglazer**—for prep
- **Cotton balls** or **soft cloth**—for prep
- **Vinyl tape**—for protecting unpainted areas of the shoes
- **Acrylic leather paints**—South Beach (turquoise), lilac, black
- **Acrylic paint thinner**—such as Angelus 2-Thin
- **Airbrush** and **compressor**
- **Blow-dryer** or **heat gun**
- **Rubbing alcohol** or **acrylic paint thinner**—for cleaning the airbrush
- **Paintbrush**
- **Detail brush**
- **Acrylic finisher**
- **Paintbrush for finisher**—(optional) alternatively, apply finisher with the airbrush

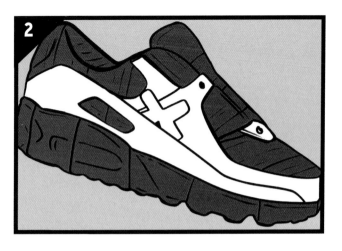

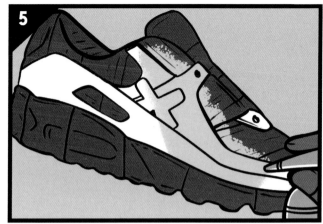

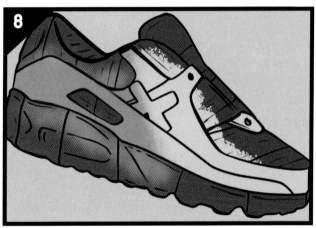

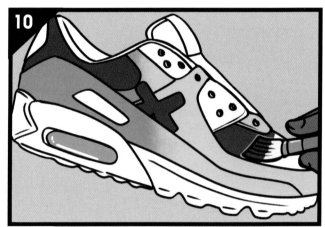

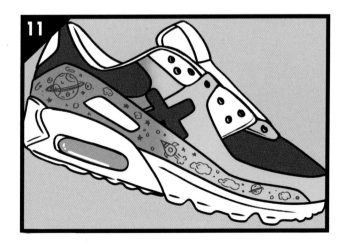

1. Start with your prep. Pull out the shoestrings and put them aside. Using acetone or deglazer with a cotton ball or soft cloth, thoroughly clean the finish off the shoes. If you haven't done prep before, follow the directions on page 19.

2. I'll be starting with airbrushing, so that means taping everything carefully because airbrushing diffuses the paint beyond the section you're aiming for. Tape the midsole, the toe box, the tongue, and the entire top of the shoe—including the opening. If you're going to be painting the first two colors with a brush, you don't need to cover the opening with tape. I use 3M red vinyl tape; use what works for you.

3. Mix the turquoise paint with Angelus 2-Thin or another acrylic paint thinner so it's the consistency of milk. Pour it into the cup of the airbrush.

5. Set the compressor to about 20 psi, and spray the toe and side fronts of the shoes. Apply several very light coats of turquoise, allowing the color to fade as you approach the midpoint on the sides. Dry the paint after each coat with the blow-dryer or heat gun.

6. Clean out the airbrush by pouring rubbing alcohol or acrylic paint thinner into the cup and running it through.

7. Mix the lilac paint with Angelus 2-Thin or another acrylic paint thinner so it's the consistency of milk. Pour it into the cup of the airbrush.

8. Repeat step 5, airbrushing the back of the shoe in two coats, allowing the color to overlap and blend with the turquoise on the sides of the shoe. Dry the paint after each coat with a blow-dryer or heat gun.

9. Repeat step 6.

10. Remove the tape. Dip your paintbrush into the black acrylic and paint the sections around the toe of the shoe and around the sides and back. Blow-dry the first coat. Paint and dry a second coat.

11. Choose your doodle. For me it was rocket ships, planets, and clouds. I painted them freehand, using my tiniest detail brush and black paint. Draw your doodles in pencil first if that makes it easier, and if you prefer, complete your doodles with a fine-point Sharpie or paint pen instead of painting them with a brush.

12. When the paint is dry, give the shoes two coats of finisher, either by brushing it on or using the airbrush, drying after each coat.

HANDMADE STENCIL

SCAN TO SEE A
TUTORIAL

As we talked about earlier, if you want to change the color of a black shoe, you've got to paint it white first. I know that sounds like you're going backwards, but you've got to do it, or there'll be a gray tinge to the new color. Despite completely changing the color of the shoe, you can still use the original black background as part of your design. If you apply a stencil directly onto the black leather before you begin airbrushing, you'll have a very cool silhouette when you're done painting.

I decided to do a city skyline silhouetted against a sunset on the side of the shoes, and I added a small silo of my home state of Virginia on the toe. You can play with this idea any way you like. You could continue the city skyline along the entire side of the shoe. You could skip the cityscape and do a silo stencil of palm trees and pyramids or mountains or anything else you like, as long as it doesn't require too much detail.

Stencils are available wherever you buy your custom materials—in crafts stores or online—but I made my own stencil out of tape for this custom.

You'll need:
- **Black leather sneakers**
- **Acetone** or **deglazer**—for prep
- **Cotton balls** or **soft cloth**—for prep
- **Vinyl tape**—for protecting unpainted areas of the shoes
- **Snap-blade knife** or **craft knife**—for cutting tape
- **Stencils**—make your own with tape or purchase
- **Surface for cutting**—(optional) cutting board or ceramic tile, for instance
- **Acrylic paint thinner**—such as Angelus 2-Thin
- **Acrylic leather paints**—white, light blue, violet, orange, black (optional) for touch-ups
- **Airbrush and compressor**
- **Blow-dryer** or **heat gun**
- **Rubbing alcohol** or **acrylic paint thinner**—for cleaning the airbrush
- **Small detail brush**—(optional) for touch-ups
- **Acrylic finisher**
- **Brush for finisher**—(optional) alternatively, apply finisher with the airbrush

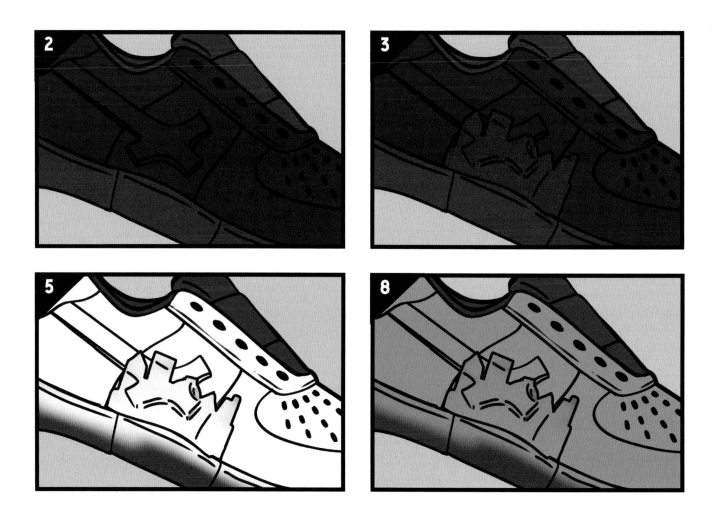

1. As always, start with your prep. Get those shoestrings out of there. Clean every surface of the shoes with acetone or deglazer and a cotton ball or soft cloth. If you haven't done prep before, follow the directions on page 19.

2. Use the tape to mask off the midsole, tongue, and sock guard around the ankle of the shoes to protect them from airbrush spray. I use 3M red vinyl tape; use the tape that works for you.

3. Carefully apply the stencils to the sides and toes of your shoes. Press all the edges down securely.

4. Mix the white acrylic paint with Angelus 2-Thin or another acrylic paint thinner so it is the consistency of milk. Pour it into the cup of the airbrush.

5. Set the compressor to about 20 psi, and spray the shoes white. Apply several coats of white, very thinly, drying the paint after each coat with the blow-dryer or heat gun.

6. Clean out the airbrush by pouring rubbing alcohol or acrylic paint thinner into the cup and running it through

7. Mix the light blue paint with Angelus 2-Thin or another acrylic paint thinner so it's the consistency of milk. Pour it into the cup of the airbrush.

8. You'll be creating a gradated sunset effect with the three colors, changing from light blue at the top, to violet, to orange at the bottom. Beginning around the area of the eyelets, airbrush with light blue, allowing the color to fade about an inch below. Blow-dry and repeat.

(continued on next page)

WHY NOT?
Make Your Own Stencil

Making your own stencil is easy. All you need is tape, a very sharp snap-blade knife or craft knife, and a cutting board or ceramic tile to cut on. If you need inspiration, look for silhouettes of different subjects online. For stencils, you want to use a good quality tape, like Scotch or 3M, that sticks to surfaces really well. Choose a vinyl tape, not masking tape. Vinyl tape has more flexibility for going over and around curves. It also has more "stick" to it than masking tape and won't allow for so much paint bleed.

Roll out a length of tape on your cutting board or tile. If you use a white or a light-colored tape, you can outline your stencil design on it in pencil or Sharpie. Then, cut along the outline with the knife. Lift the completed stencil and apply it to your shoe, carefully smoothing down all the edges. Vinyl tape has some stretch to it; be careful not to stretch it too much when you apply the stencil to your shoe because it will retract, and that can cause wrinkles or gaps where paint can seep underneath.

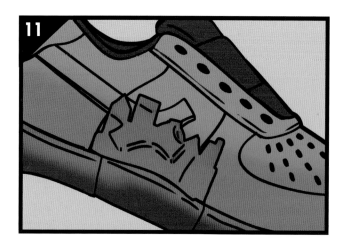

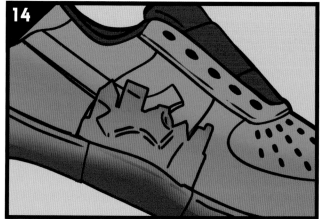

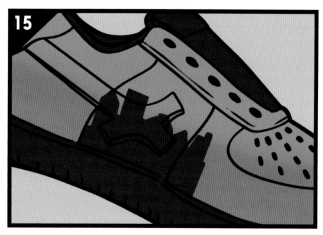

9. Clean the airbrush by running rubbing alcohol or acrylic paint thinner through it.

10. Mix the violet paint with Angelus 2-Thin or another acrylic paint thinner so it's the consistency of milk. Pour it into the cup of the airbrush.

11. Airbrush a band of violet all the way around the shoe, allowing the spray to mix and blend with the light blue above it. Blow-dry and repeat.

12. Repeat step 9.

13. Mix the orange paint with Angelus 2-Thin or another acrylic paint thinner so it's the consistency of milk. Pour it into the cup of the airbrush.

14. Complete the sunset by airbrushing a band of orange all the way down to the midsole and all the way around the shoe. Allow a light spray of orange to overlap and blend with the violet color. Blow-dry and repeat. The painting is complete.

15. Peel off each stencil; use the point of your craft knife to help you lift it. Peel off the tape masking the midsole, tongue, and padding.

16. Touch up the edges of the stenciled silhouettes with the detail brush and black paint if necessary.

17. Paint or airbrush two coats of acrylic finisher on the shoes, blow-drying after each coat.

HOT STUFF

SCAN TO SEE A
TUTORIAL

If you've been wanting a little magic, a little flash to happen when you wear your custom, then this is the project for you. When these kicks are exposed to heat or sunshine, they change color; move to the shade or a cooler temperature, and the color changes back.

The magic comes in a package of SolarColorDust—a thermochromic chameleon pigment, which is a fancy way of saying "powdered color that's heat-sensitive, sun-sensitive, and UV-light sensitive."

To make the dust do its stuff, you mix it with neutral acrylic leather paint and paint it onto a white surface— such as a leather sneaker. Once you've mixed it, it goes on just like any other paint. Be careful not to leave your color-dust sneakers out in the sun for prolonged lengths of time; the pigments can become sunburned and will no longer change color.

For my custom, I used an airbrush to apply the color-dust paint to the upper part of these Jordan 1s and around the front of the toe and back of the heel. Then I hand-painted the black sections with a brush.

You'll need:
- **White leather sneakers**
- **Acetone** or **deglazer**—for prep
- **Cotton balls** or **soft cloth**—for prep
- **Vinyl tape**—for protecting unpainted areas of the shoes
- **Craft knife**—for cutting tape
- **Neutral acrylic leather paint**
- **SolarColorDust**—different colors come in a single package (I used red that changes to yellow)
- **Small bowl** or **container**—for mixing dust and paint
- **Stick** or **spoon**—for mixing the color-dust paint
- **Acrylic paint thinner**—such as Angelus 2-Thin
- **Airbrush and compressor**
- **Blow-dryer** or **heat gun**
- **Acrylic leather paint**—black
- **Paintbrush**
- **Acrylic finisher**
- **Brush for finisher**—(optional) alternatively apply finisher with the airbrush

1. Start with your prep. Take out those shoestrings and set them aside. Clean every surface of the shoes with the acetone or deglazer and cotton balls or a soft cloth. If you *haven't* done prep before, follow the directions on page 19.

2. Decide where you want your color-dust color, then tape every other area of your shoes. Remember, with airbrushing it's especially important to tape well because the paint diffuses onto all nearby surfaces. I use 3M red vinyl tape; use the tape that works for you.

3. Mix the color pigment with the neutral paint in a small bowl or container, stirring it thoroughly.

4. Remember, for airbrushing the paint needs to be the consistency of milk. If your mixture needs thinning, add a small amount of Angelus 2-Thin or another acrylic thinner and a tiny bit more of the color dust to correct the consistency.

5. Pour the paint into the cup on top of the airbrush. Set the compressor to 20 psi and begin to spray on the color.

6. Dry the first coat of color with the heat gun or blow-dryer. You will immediately see the color changes taking place on the surface of your shoes when you apply the heat.

7. Airbrush on a second coat of color-dust color and dry it with the heat gun or blow-dryer.

8. Pull off the tape.

9. Carefully apply the first light coat of black paint in the sections where you want it. Dry it with the heat gun or blow-dryer. Apply a second coat of black paint and dry it again. Leaving some areas white will make the overall look really crisp and sharp.

10. When your shoes are completely dry, give them two coats of acrylic finisher, using the heat gun to dry each coat. If you prefer, you can apply the two coats of finisher with your airbrush.

11. Step outside and see what happens.

HEAD'S UP!
Let's Talk about Measuring
In order for the color changes to work properly when your kicks are complete, you need to pay attention to the manufacturer's directions for mixing it. The recommended ratio is 1 gram (¼ teaspoon) of SolarColorDust to 1 fluid ounce (2 tablespoons) of clear base. (Neutral acrylic leather paint looks white in the bottle, but it dries clear, colored only by the pigment of the dust.) Follow the directions on the package: If you don't use enough of the dust, the chameleon effect might not be as apparent as you want it to be. The color should be quite vibrant when you mix the dust into the paint.

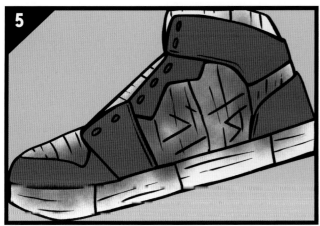

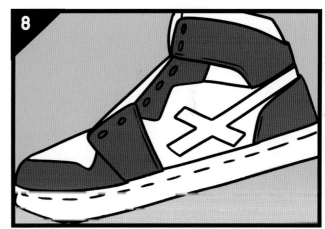

125

COLOR WAVES

SCAN TO SEE A
TUTORIAL

This shoe will give you some interesting challenges to work with. You can use this aero-design to create different wavy stripes of color, but here's the thing: The stripes on this shoe alternate between mesh and leather—two completely different textures and materials. I used airbrushing on most of the leather parts, and hand painting on the mesh and around the eyelets and tongue. The painting is easy enough, but in order to get a really clean line between the different color stripes, you will have to up your taping skills.

I used four colors for my custom. You can see the airbrushed gradation on the side of the shoe, going from gift-box blue in the front, through turquoise, to blue in the heel area. The mesh sections I did with black paint and a brush. Mine almost look like they started out as black shoes, but you could do any color combinations you like—pastel stripes, rainbow stripes, neon stipes, maybe glow in the dark.

Go in whatever direction you like with this one.

You'll need:
- **White leather sneakers**
- **Acetone** or **deglazer**—for prep
- **Cotton balls** or **soft cloth**—for prep
- **Vinyl tape**—for protecting unpainted areas of the shoes
- **Craft knife**—for cutting the tape
- **Acrylic leather paints**—gift-box blue, turquoise, blue, black
- **Acrylic paint thinner**—such as Angelus 2-Thin
- **Airbrush and compressor**
- **Blow-dryer** or **heat gun**
- **Rubbing alcohol** or **acrylic paint thinner**—for cleaning the airbrush
- **GAC 900**
- **Paintbrush**—for black paint
- **Small detail brush**
- **Acrylic finisher**
- **Paintbrush for finisher**—(optional) alternatively apply finisher with the airbrush

1. Start with your prep. Pull out the shoestrings and put them aside. Using acetone or deglazer with a cotton ball or soft cloth, thoroughly clean the finish off the shoes. If you haven't done prep before, follow the directions on page 19.

2. Taping is always an important part of airbrushing and taping around the waves in this shoe's design is a little time-consuming, but you've got to do it. Press the edges of the tape down securely and be sure to cover the opening in the shoe so no paint gets inside. I use 3M red vinyl tape; use what works for you.

3. For each of the three shades of blue you'll be using in your airbrush, mix the paint 1:1 with Angelus 2-Thin or another acrylic paint thinner to the consistency of milk before pouring it into the airbrush's cup. For this shoe, I started with the lightest shade—gift-box blue—at the toe, followed by turquoise on the sides, and blue at the heel, cleaning the airbrush between colors by running rubbing alcohol or acrylic paint thinner through it.

4. Set the air compressor to 20 psi, pour the first color into the airbrush cup and spray the front of the shoe, extending the color onto the sides. Blow-dry the first coat. Airbrush a second coat of color and dry again.

5. Clean the airbrush by running rubbing alcohol or acrylic paint thinner through it.

6. Repeat steps 4 and 5 with the second color, lightly overlapping the first color toward the front and extending the color into the heel area.

7. Repeat steps 4 and 5 with the third color, airbrushing the heel of the shoe and lightly overlapping the second color on the sides.

8. Step back to make sure you have solid color coverage where you want it and smooth gradations where you want them. Go back and tweak the color if you need to.

9. When the paint is thoroughly dry, tape again. Cover the airbrushed section with tape.

10. With the craft knife, carefully cut away the tape covering the top wavy leather stripe.

(continued on next page)

11. Repeat steps 4–8, giving the stripe the same gradated range of color as the section below it.

12. Clean out the airbrush. You're ready to paint by hand.

13. Because you'll be painting on mesh, mix the black paint 1:1 with GAC 900. (Make sure you have good ventilation.)

14. Using a small brush, carefully paint all the areas you want black. On my shoes, I left the small swoosh and the stripes on the tongue white when I painted the black areas.

15. Blow-dry the black paint. Give the black areas a second coat of paint and dry again.

16. Use the detail brush to paint the swoosh and tongue striping turquoise.

17. When the paint is dry, give the shoes two coats of finisher, either by brushing it on or with the airbrush, drying after each coat.

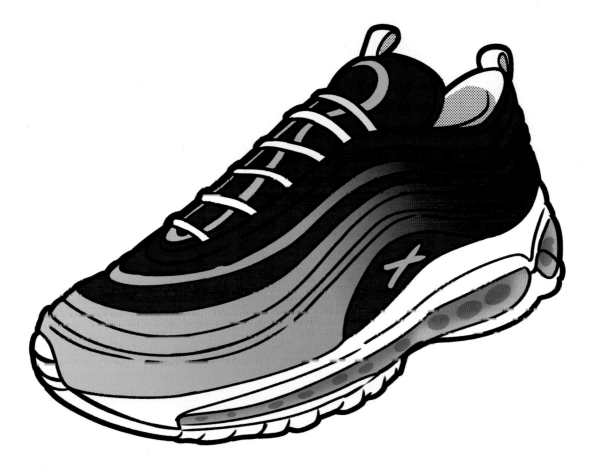

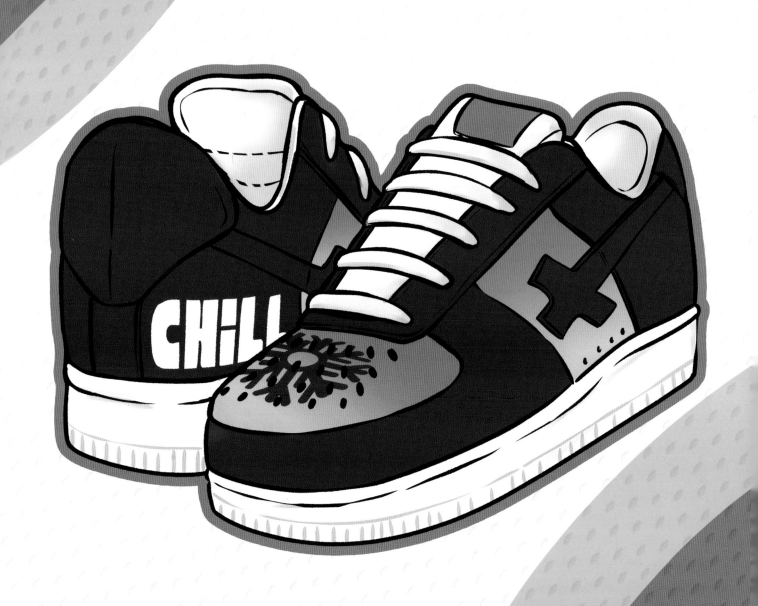

TEAM SPIRIT

SCAN TO SEE A
TUTORIAL

This custom combines airbrushing, hand painting by brush, and a little bit of logo stenciling to capture the spirit displayed on team jerseys. You can follow these same steps, using different colors and logos to create a custom for any team you like. (Look to the illustrations as an example of how you can use this same technique with your favorite colors.)

This custom will take a little minute of your time. Combining airbrushed areas with solid-color areas on a shoe means you'll need to do thorough taping to mask the solid-color areas each time you use the airbrush. And combining a number of colors means you'll need to wait for each color to dry completely before you can pull off the tape and work on the next section. Yes, I know it's slow, but that's how you get these kicks to pop.

You'll need:
- **White leather sneakers**
- **Acetone** or **deglazer**—for prep
- **Cotton balls** or **soft cloth**—for prep
- **Vinyl tape**—for protecting unpainted areas of the shoes
- **Snap-blade knife** or **craft knife**—for cutting tape
- **Acrylic paint thinner**—such as Angelus 2-Thin
- **Acrylic leather paints**
- **Airbrush and compressor**
- **Blow-dryer** or **heat gun**
- **Rubbing alcohol** or **acrylic paint thinner**—for cleaning out airbrush
- **Paintbrush**—for black paint
- **Stencils**—for toe and heel team logos
- **Small detail paintbrush**
- **Acrylic finisher**
- **Brush for finisher**—(optional) alternatively, apply finisher with the airbrush

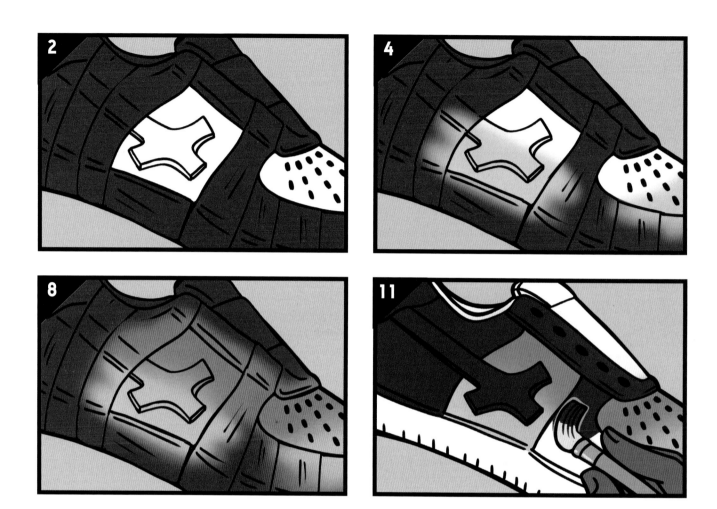

1. Start with your prep, as always. Pull out those shoestrings and set them aside. Clean the entire surface of your shoes with acetone or deglazer and cotton balls or a soft cloth. If you haven't done prep before, follow the directions on page 19.

2. You will be airbrushing the side quarters and the toe box in this custom. Carefully mask the rest of the shoe with tape and trim the ends with a craft knife. I use 3M red vinyl tape; use the tape that works for you.

3. Use the acrylic paint thinner to thin a small amount of your base color so it's the consistency of milk. Pour the paint into the cup on your airbrush.

4. Set the pressure of the compressor to about 20 psi and give the side quarters and toe box of your shoes a light airbrushing. Ultimately, the color in these sections is going to gradate from top to bottom, so aim for a denser application at the bottom and lighter as the color rises.

5. Dry the first coat of paint with the heat gun or blow-dryer. Apply a second coat and dry it as before.

6. Clean out the airbrush by pouring a small amount of rubbing alcohol or acrylic paint thinner through it (aiming the spray away from your shoes).

7. Thin a small amount of your top color paint to the consistency of milk and pour it into the cup on top of the airbrush.

8. Color the same sections of the shoes as before, allowing this color to be denser at the top of each section, and lighter where it overlaps the bottom color. Try to get a good blend where the two colors overlap for a soft gradation.

9. Blow-dry the first coat of your top color. Airbrush a second coat and dry the second coat. Clean out your airbrush as before in step 6.

10. Remove the tape protecting the upper part of the shoe. Leave it in place on the midsole.

11. Using the paintbrush and black acrylic paint, carefully give all the white areas of the shoe— *except the sections with the tongue and the eyelets*—a light coat of paint. Paint the entire swoosh.

(continued on next page)

DYK?

When I need a specific team or designer logo, I make them to size on a Cricut Explore Air 2 stencil-cutting machine—but that's a $200 investment. If you're only going to be stenciling occasionally, you can buy just about any stencil you might want online. For another version of custom, Google "NBA logo stencils" and explore your options.

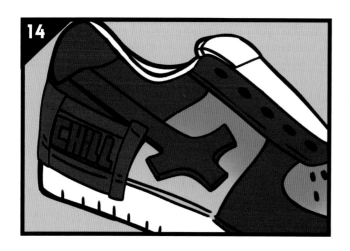

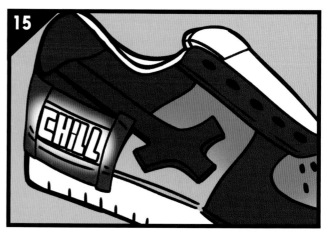

12. Dry the first coat of black paint with the blow-dryer or heat gun. Paint and dry a second thin coat of black paint.

13. Rinse out the brush. Give the section with the eyelets and tongue two thin coats of paint, drying each coat with the blow-dryer or heat gun.

14. Place the logo stencils on the outside heel section and across the toe of the shoe. Be sure the stencil is smoothly and tightly in place—press down along all the cut lines. Mask the entire section around the stencil with tape again to protect it when you airbrush the logo.

15. For this custom, the logo on the toe of the shoe will be white. Thin a small amount of white paint with Angelus 2-Thin so it is the consistency of milk. Give the logo two coats of white paint, drying it after each coat with the blow-dryer or heat gun.

16. The outer heel of the shoe is black and the logo will be whichever color you desire. To avoid a muddy-looking result, first spray the logo white—a single coat should be enough. Clean the airbrush by running rubbing alcohol or acrylic paint thinner through it.

17. When it's dry, thin a small amount of paint to the consistency of milk and give the logo two coats of paint, blow drying it after each coat.

18. Remove the tape and stencils. With the tiny detail brush, highlight the shoes' logos on the midsoles.

19. Get out your acrylic finisher, brush, and heat gun and, when your shoes are completely dry, give them two coats of finish, using the heat gun to dry the acrylic with each coat. If you prefer, you can apply the two coats of finisher with your airbrush.

HEAD'S UP!
Let's Talk about Stencil Bleed

It's so frustrating when you're trying to achieve a perfect outline with stencils or tape and instead, the outlines look fuzzy because paint seeps underneath. There's an easy trick to avoid that problem. Carefully press the stencil into place. Then, make the first coat of paint you apply the same color as the background (alternatively, you could do this with a coat of clear spray paint).

Let that first coat dry thoroughly. It will seal all the edges of the stencil or tape, and once it's dry, it will block any subsequent sprayed or painted color from seeping underneath.

Paper, Cloth, Glitter, and SHINE

Who said custom has to be painted on? In this chapter we'll get out the glue, break open our secret stash of rhinestones and glitter, prowl the aisles of fabric stores for animal prints, and call in a few favorite superheroes—BAM!—to help inspire unique surface texture and collage ideas. I'll tell you everything you need to know about adhesives, cutting tools, and finishes for customizing your kicks with texture, imagery, and a little bit of shine!

FABRICATION TRANSFORMATION

SCAN TO SEE A
TUTORIAL

If you like the idea of argyle on your kicks but have second thoughts when it comes to painting all those squares and lines by hand, there's an easy way around that—glue them on instead!

I don't usually use masking tape with my custom because it doesn't stick as well as the acrylic tapes, so it's not the best choice for painting or airbrushing—but when it comes to making templates, its medium stickiness makes it exactly the right choice. To create a template, you'll cover individual sections of the shoe with the tape and press it down firmly. Then, when you cut around the shape with a craft knife and lift the cutout (the template), you transfer it to a piece of fabric. Having the exact shape will guarantee that the piece you cut out of fabric will fit the section of the shoe perfectly.

Of course argyle is not your only choice for this kind of simple custom—you can use other types of fabric as well, but if you do, choose one that doesn't fray easily—knits and suede cloth and faux leather are good choices—and is fairly dense, so the glue will not bleed through.

You'll need:
- **Leather sneakers**
- **Acetone** or **deglazer**—for prep
- **Cotton balls** or **soft cloth**—for prep
- **Piece of argyle fabric**
- **Wide masking tape**
- **Craft knife**
- **Scissors**
- **E6000 craft adhesive**
- **Toothpicks**—for spreading the glue

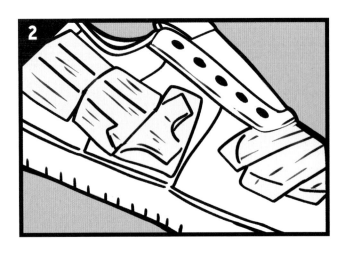

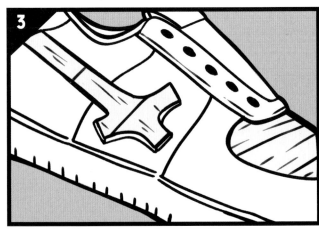

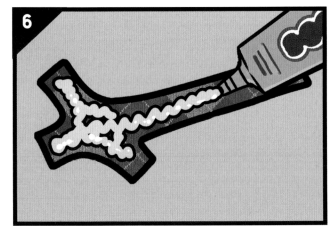

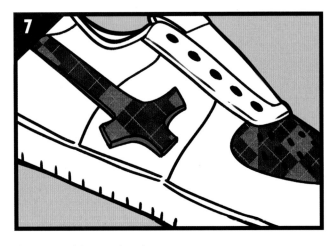

1. Decide where you'll apply the fabric on your shoes—for my shoes, it's the toe box and swoosh. You only need to do your prep in those areas. Thoroughly clean those areas with acetone or deglazer and cotton balls or a soft cloth.

2. Cover the toe box and swoosh on your shoes with masking tape. Press it down firmly around the entire outline of each shape.

3. With a sharp craft knife, cut out the shapes. Pull off and discard the excess tape.

4. Lift the masking-tape templates and transfer them to the fabric.

5. Cut out the shapes with the scissors.

6. Turn the cutouts facedown. Drizzle the E6000 adhesive evenly over the back of each. Spread the glue as needed with toothpicks to avoid lumps.

7. Press and glue each fabric cutout into place.

8. Let the shoes sit for twenty-four hours to allow the glue to dry thoroughly. And you're ready to pop out.

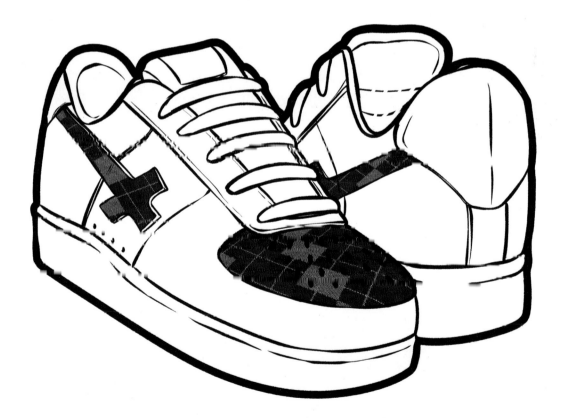

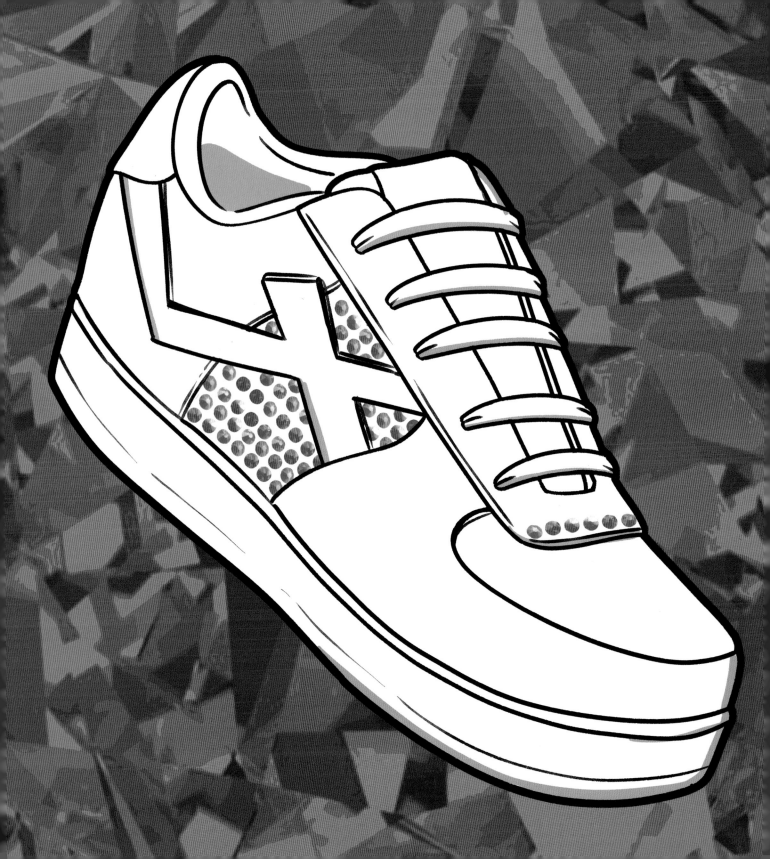

BEDAZZLED FLASH

SCAN TO SEE A
TUTORIAL

Here's a good-looking custom with no paint, no drawing, and no stenciling required—it's simple—anyone can do it—but it does take time to glue on one bedazzling gem at a time. I've done a straightforward design, but there are no end of ideas you can adapt to make this custom your own. Bedazzle the toe, the swoosh, the entire shoe, arrange the gems in stripes of color or in patterns of sparkling flowers or fireworks. With these kicks you can be sure you'll make heads turn.

I recommend using E6000 adhesive for this project—and really any project that requires gluing materials onto your kicks. It's an industrial-strength glue and has an especially good bond with leather. It also gives you good adhesion when you're working with glass, plastic, metal, and just about any other kind of craft material. The bottle's pointed nozzle makes it easy to get the glue exactly where you want it, and not all over your fingers. You can also purchase the glue with a variety of nozzles that will work for many different types of applications.

You'll need:

- **Leather sneakers**
- **Acetone** or **deglazer**—for prep
- **Cotton balls** or **soft cloth**—for prep
- **E6000 craft adhesive**
- **Multicolor bedazzling gems**
- **Pair of tweezers**—tweezers with angled tips make it easier to pick up and place small gems
- **Acrylic finisher**
- **Paintbrush**—for applying the finisher
- **Blow-dryer** or **heat gun**

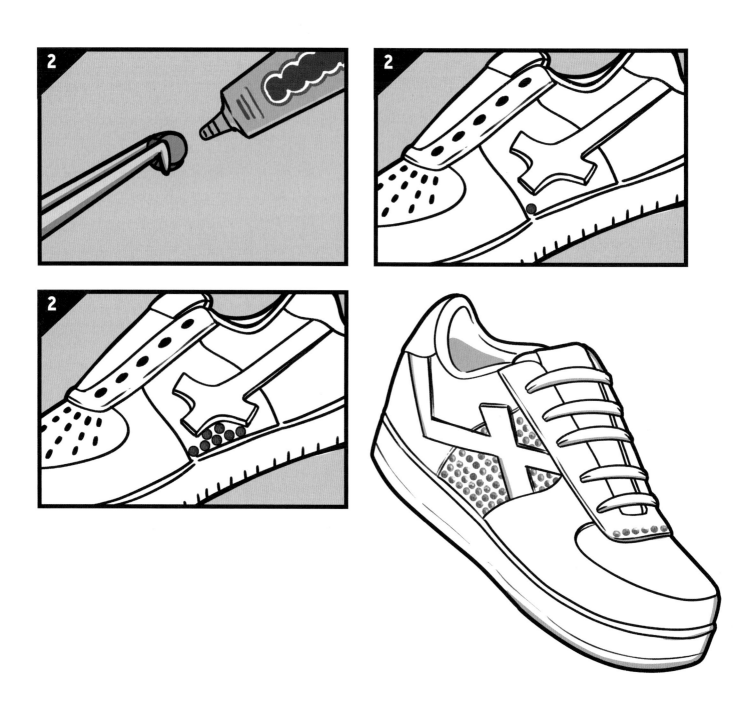

1. Decide where you'll apply the bedazzling on your shoes. You only need to do your prep in the areas you will bedazzle. Thoroughly clean those areas with acetone or deglazer and cotton balls or a soft cloth.

2. Pour the gems onto a plate. Use the tweezers to pick up one gem at a time. With your other hand, squeeze a dot of glue onto the back of the gem and press it firmly into place on your shoe. That's all there is to it!

3. When the glue has dried thoroughly, give the bedazzled sections two coats of finisher, drying each coat with the blow-dryer or heat gun.

HEAD'S UP!
One thing to remember—although E6000 gets tacky quickly, it actually takes quite a while to dry thoroughly. When you've finished bedazzling your kicks, let them sit for twenty-four hours before wearing them.

BRUSHED-ON GLITTER

SCAN TO SEE A
TUTORIAL

The secret behind the success of this custom is neutral paint. It comes in a little bottle like every other kind of acrylic leather paint. It looks just like white paint when you pour it out, but it dries completely clear. That means you can mix it with other pigments and with materials like glitter, which will not flake off when the paint dries.

Applying glitter in paint that has been specially formulated for use on leather shoes means you avoid the possibility of ridges forming in the surface, which can happen when you try to attach glitter with glue. The glitter-paint goes on thinly with each coat. It will look sparse at first, so to get an even coverage of glitter on these shoes, I gave each section two coats of hot pink paint first and then applied four coats of pink glitter-paint.

I tried to stay low-key with this custom—and not go too crazy with the glitter—but if you want, you could go full-out with different colors of glitter in different sections of the shoes. One of the fun things about the Air Max kicks I used for this custom, is that they're made up of so many distinct shapes and panels that you can call out with different colors.

You'll need:
- **White leather sneakers**
- **Acetone** or **deglazer**—for prep
- **Cotton balls** or **soft cloth**—for prep
- **Vinyl tape**—for protecting unpainted areas of the shoes
- **Craft knife**—for cutting tape
- **Acrylic leather paints**—hot pink, black
- **Blow-dryer** or **heat gun**
- **Neutral acrylic leather paint**
- **Hot pink extra-fine glitter**
- **Small bowl** or **container**—for mixing neutral paint and glitter
- **Paintbrush**—for paint
- **Paintbrush**—for glitter paint
- **Blow-dryer** or **heat gun**
- **Acrylic finisher**
- **Brush**—for applying finisher

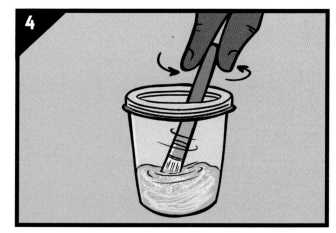

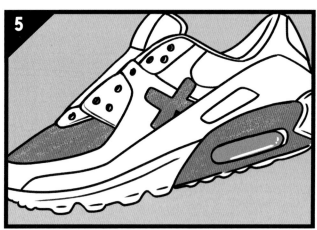

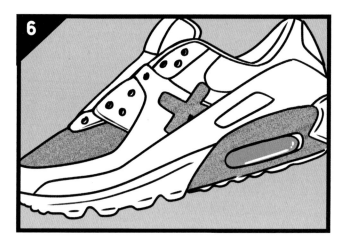

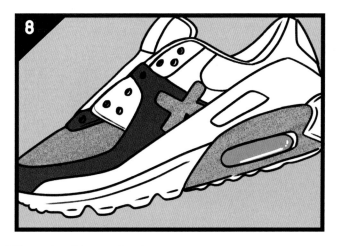

1. Start with your prep, as always. Pull out those shoestrings and set them aside. Use acetone or deglazer and cotton balls or a soft cloth to clean the areas of your shoes you'll be painting and glittering—you don't need to clean the rest of the shoe. If you haven't done prep before, follow the directions on page 19.

2. Tape the sections of the shoes you want to remain white. I use 3M red vinyl tape; use the tape that works for you.

3. Begin with the pink paint. On my shoes I painted the toe box, the swoosh, the back of the heel, and the "air" section on the midsole. Brush on the first coat of pink paint. Dry it with the blow-dryer or heat gun. Then paint and dry a second coat.

4. Pour some neutral paint into a small bowl or container. Pour in a good amount of fine glitter and mix it in well. The mixture should be fluid enough to paint with but also really saturated with glitter.

5. Carefully apply a first coat of glitter-paint to the pink areas of the shoes. If you use a heat gun to dry the paint, make sure the heat is no higher than medium and don't hold the heat gun too close to the glitter—glitter is made from very thin plastic.

6. Reapply the glitter-paint for a total of four coats and allow each coat to dry thoroughly.

7. Make sure the areas you intend to paint black are completely free of any loose bits of glitter.

8. Apply two coats of black paint to those areas, drying them with the heat gun or blow-dryer after each coat. Pull off the tape.

9. Get out your acrylic finisher, brush, and heat gun and, when your shoes are completely dry, give them two coats of finisher, using the heat gun to dry each coat.

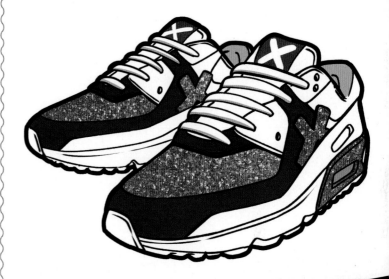

DYK?
You've probably discovered at some point how hard it is to get glitter off your skin. The best way to get rid of it? Pull it off with adhesive tape.

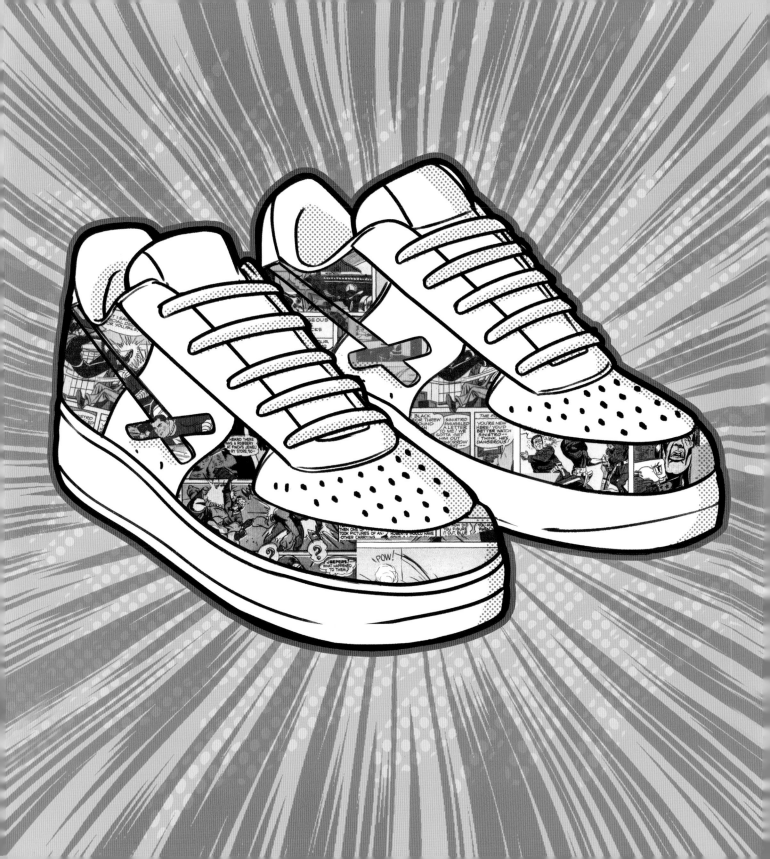

CUT-PAPER COLLAGE

SCAN TO SEE A
TUTORIAL

Have you ever thought of pasting pictures on your shoes? You can do this custom with any kind of printed paper you like—it could be sheet music, it could be postage stamps, it could be newspaper—but here's the thing: The paper should be fairly thin. You're going to glue cut-up pieces of paper directly onto your shoes, so the paper has to be thin and flexible enough to drape over the rounded parts of your shoe—and over seams and stitching—when it's wet with glue.

I'm a big Marvel Comics fan, so I'm going to attach Marvel Comics to my kicks! Pretty crazy, but before we start, I want to give a big shout-out to Sam Alxr (@samalxr), who was the first artist I ever saw do this kind of custom. If you're going to cut up a comic book for this, find an old one you don't mind destroying.

The glue we'll use is Mod Podge. It's actually a glue, sealer, and finisher all in one. It looks like regular craft glue but it comes in different finishes—from matte to glossy. For this project Mod Podge is what you want— don't substitute regular glue.

You'll need:
- **Leather sneakers**
- **Acetone** or **deglazer**—for prep
- **Cotton balls** or **soft cloth**—for prep
- **Comic book or other printed paper**
- **Scissors**
- **Mod Podge**
- **Paintbrushes**
- **Craft knife** or **snap-blade knife**—you'll need a sharp, new blade

1. You've got to get that factory finish off so the glue in the Mod Podge can get a good grip on the leather. If you leave the finish on, all that gluing won't hold—you'll be wasting your time. So, pull out your shoestrings and set them aside. Decide which sections you'll collage, and then clean just those sections with acetone or deglazer and cotton balls or a soft cloth.

2. Open your comic book or other printed papers and start thumbing through. Every time you see an image you like—close-up detail or whole frame—cut it out. Your cutouts should be small. The larger they are, the more creases and wrinkles they'll have when you go to bend and smooth them over a rounded or stitched part of your shoe. Keep cutting until you have a good stack of small images ready to go.

3. Open your jar of Mod Podge and get out your brush. You're going to work in one small area at a time—don't try to cover too large an area with Mod Podge all at once, because it will start drying before you're ready to use it.

4. Brush some Mod Podge onto a section of your shoe, just the right size for your first cutout. Then brush Mod Podge onto the back of the cutout— you need to have Mod Podge on both surfaces.

5. Stick the cutout into place, rubbing it down carefully with your fingers, pressing it into any seams or ridges.

6. Do the same with the next cutout, overlapping the edge of this one with the first.

7. Continue to do the same, one cutout after another, working your way over a small section of the leather part of your shoe.

8. While the Mod Podge is still wet, it's time to get out your craft knife or snap-blade knife and trim the edges of the cutouts that overhang areas like the top rim of the rubber midsole, the edges of the swoosh, the facing around the eyelets, and the sock guard around the ankle opening.

9. Use your knife to trim those overhanging edges of the cutouts. Carefully use the blade and your thumbnail to tuck the cut edges tightly and cleanly into the seams.

10. Move on to the next section, repeating steps 4–9 until you've finished all the sections you want to cover.

11. Set the shoes aside and let them dry overnight.

12. Give the collaged areas two coats of Mod Podge as a sealer, allowing each coat to dry before applying the next.

HEAD'S UP!
Let's Talk about Sharp Blades
You need a razor-sharp blade to cut damp paper. As you will learn, to your aggravation if you try to do steps 8 and 9 with a dull blade, the damp paper will pull, wrinkle, and tear as you drag the blade through it. A razor-sharp blade will make a clean cut. Start with a fresh blade and be sure to wipe it clean after each cut, so that Mod Podge doesn't build up and dry on it. Or use an inexpensive snap-blade knife that you can renew after every few cuts, guaranteeing a razor-sharp edge.

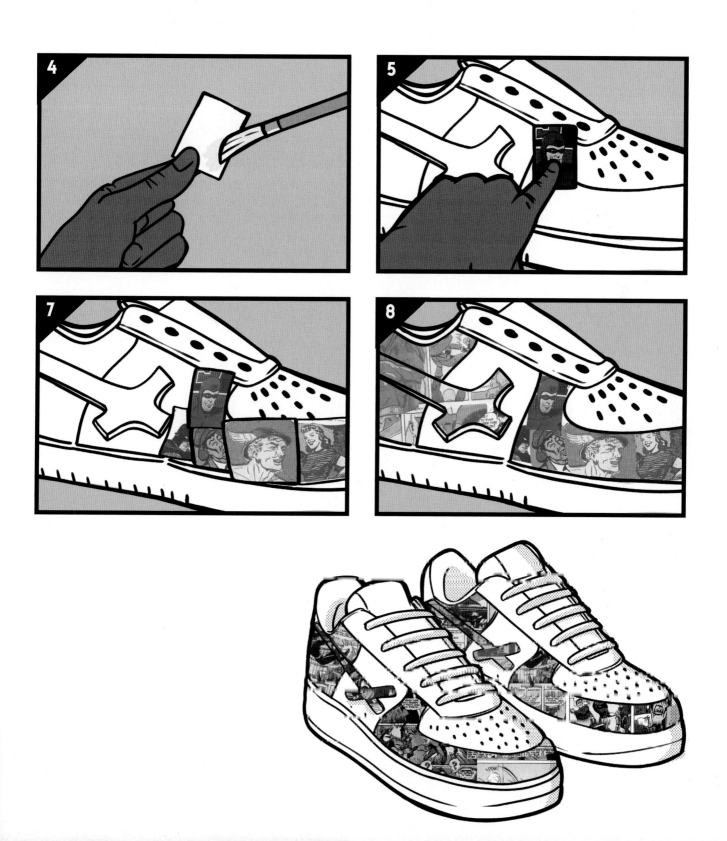

SNEAKERS
IN POP CULTURE

A TIMELINE OF KICKS
IN MUSIC AND MOVIES

Back in the 1950s, when stars like Marlon Brando, James Dean, and Elvis Presley appeared onstage or on-screen in sneakers, fans took note of their cool, casual style—but the link between pop culture and shoe brands was minimal. Since the 1980s and the launch of custom, however, the dance between street fashion and showbiz, high fashion and sneaker design, has taken off—one sector influencing the other, round and round, with the creativity of custom artisans and designers getting more colorful every day. Here are a few pop-culture moments.

1982

Actor Sean Penn wears checkered Vans in the film *Fast Times at Ridgemont High* and sales of the shoes skyrocket, turning the small family business specializing in custom-made shoes into a household name worldwide.

1986

Hip-hop group Run-D.M.C. scores big with "My Adidas," giving the brand a major place in pop culture and a new shoe called the Superstar Run DMC.

1987

"Nobody puts Baby in the corner"—certainly not if she's wearing her Keds. When Jennifer Grey starred in *Dirty Dancing*, wearing the classic white kicks, it drove the brand's sales ten times in a single year. Superstar Taylor Swift is the Keds ambassador today.

1994

Tom Hanks wears the red, white, and blue Nike Cortez in *Forrest Gump*, rekindling the popularity of Nike's first commercial running shoe. More than 700 versions of the Cortez have been released since its debut in 1972.

2009

Maverick dresser and *Twilight* vampire, actress Kristen Stewart rocks the red carpet at the MTV Movie Awards in her Converse high-tops and Yigal Azrouël dress, setting off a vogue for mixing kicks with high fashion.

2014

Multi-Grammy winner Rihanna melds her Fenty Beauty line with Puma when the shoe company looks for a recognizable female representative for its new sports-with-attitude presence. Rihanna's first shoe, the Rihanna Fenty Puma Creeper, sold out in three hours and won Shoe of the Year. She was made creative director of the brand in 2016.

2021

Oscar- and Grammy-winning, sneaker-loving, singer-songwriter Billie Eilish collaborates with Nike, opting to return to the roots of custom for a new take on the Air Jordan 1. Colored lime green in a nod to her own past, Billie's AJ1KOs are 100 percent vegan and made of sustainable materials.

ABOUT XAVIER

Snap! By day, he's a software engineer. By night, he customizes kicks and films fun tutorial YouTube videos for his thousands of followers. Xavier Kicks (aka Xavier Crews) has been customizing shoes for more than ten years and has recorded more than 120 videos. A graduate of Virginia State University, Xavier often gives back to his community by giving away his customized shoes, basketballs, iPads, and more. His goal in creating his videos for beginners, is to teach creative techniques so viewers can build their skills and enjoy making things by hand. He lives, works, and inspires from his home in Danville, Virginia.

ACKNOWLEDGMENTS

I would like to acknowledge The Quarto Group for making this book possible. I want to personally thank Jonathan, Judith, Brooke, and Lydia who played a major role in making this book happen.

I would also like to thank my parents for having faith in me and pushing me every day. I am sincerely grateful to my manager, Maia, my friends, and supporters who have supported me through my whole custom shoe journey.

A

Acetone, 15, 17, 21
Acrylic finishers, 15, 23
Acrylic leather paints, 15, 16, 27
 for airbrushing, 104, 105–137
 on canvas, 77
 projects using, 29–59, 75–77, 91–93, 99–
 101, 109–119, 123–137, 149–151
Adidas sneakers, 79, 157
Airbrush(ing)
 about, 104
 cleaning your, 107
 equipment for, 104–105
 paints for, 16
 projects using, 37–39, 41–43, 71–77,
 95–101, 109–137
 techniques for, 106–107
Air Force 1s, 11, 14, 33–39, 63–65, 83–85,
 109–111
Air hoses, 104, 105
Air Jordans, 79
Air Max sneakers, 113–115, 149–151
All Stars, 78
Alxr, Sam
Angelus 2-Thin, 99–101, 105, 107,
 109–129, 133–137

B

Bandana design shapes, 55–59
Black leather sneakers, 109–111, 117–121
Black sneakers, 75–77, 99–101

C

Camo design, 63–65
Canvas slip-ons
 Paint Pen Doodling, 71–73
 Sharpie Tie-Dye, 87–89
Canvas sneakers, 8, 9
 Galactic Splatter, 99–101
 leather paint on, 77
 markers on, 17
 Paint Pen Doodling on, 71–73
 Paint Pen on Dark Color, 75–77

Cartoon custom sneakers, 33–35
Chuck Taylor All Stars, 78
City skyline, 117–118
Cleaning sneakers, 20–21
Collage, 153–155
Color-dust sneakers, 123–125
Compressor, 104, 105
Converse high-tops, 75, 78, 157
Craft knife, 22
Curved lines, 33–35
Customized/customizing sneakers
 frequently asked questions about,
 10–12
 materials for creating, 15–18
 practicing and planning your design
 for, 24–25
 workspace for creating, 14

D

Deglazers, 15
Design(ing), 24–25
Doodling and drawing, 14, 25, 53, 67–73,
 113–115
Dragon Kicks, 41–43

E

E6000 Craft Adhesive, 141–143,
 145–147

F

Fabric, on sneakers, 141–143
Fabric paints, 15
Factory Laced Shoe Cleaner, 21
Finishing, 23
Flicking paint on sneakers, 91–93
FrogTape, 18

G

GAC 900, 15, 75–77
Galaxy Vans, 99–101
Gems, 145–147
Glitter, 149–151

H

High-tops, 9, 37–39, 51–53, 75–77, 157
Hydro dripping, 16, 18, 95–97

I

Insoles, 21

K

Keds, 157

L

Leaf and flower design, 53
Leather Deglazer, 15
Leather paint. *See* Acrylic leather paints
Leather sneakers, projects using, 29–31,
 41–43, 55–59, 63–69, 83–85, 91–97,
 141–147, 153–155. *See also* Black
 leather sneakers; White leather
 sneakers
Linework, 51–53, 67–69

M

Marbled design, 83–85, 95–97
Markers, 17
Marvel Comics, 153–155
Masking tape, 18, 119, 141–143
Materials and tools, 15–18
Matte finishes, 15, 23
Mod Podge, 18, 153–155
Movies and music, sneakers in, 156–157

N

Night sky, 99–101
Nike, 9, 79, 157

P

Paint pens
 about, 16–17, 61
 designing with, 73
 practicing with, 25, 65
 projects using, 63–77
Paints and painting, 15. *See also* Acrylic
 leather paints; Airbrush(ing); Tooth-
 pick painting
 for less expensive sneakers, 11
 with plastic knives, 91–93
 Rust-Oleum, 95–97
 with toothpicks, 18, 29–31, 55–59
Paper cutouts, 153–155
Plaid design, 45–49
Plastic knives, painting with, 91–93
Pleather materials, 11
Plimsolls, 9
Posca pens, 17, 63, 71–73, 75
Practice work, 25, 31, 57
Prepping, 19–22
Puma sneakers, 79, 157

R

Reebok, 79
Rubber-soled shoes, 8, 9
Rubber toe caps, 9
Rubbing alcohol, 17, 87–89, 101, 107,
 109–121, 127–129, 133–134, 137
Rust-Oleum paints, 16, 95–97

S

Satin finishes, 23
Sharpie pens, 17, 25, 43, 51, 69, 87–89, 115
Shaving cream, 83–85
Shoe dye, 83–85
Shoelaces, 19, 85
Single-color gradation, 107
Sketchbook, 25, 31, 33, 53, 57, 73, 77, 101
Slip-ons. *See* Canvas slip-ons

Sneakers
 cleaning, 20–21
 design history of, 9
 finishing, 23
 in music and movies, 156–157
 in sports, 78–79
 taping, 22
SolarColorDust, 123–125
Splatter, paint, 91–93, 99–101
Sports, sneakers in, 78–79
Spray paints, 16
Sprinkles, 29–31
Stencils, 117–121, 133–137
Stripes and striping, 9, 37–39, 45–49, 127–
 131. *See also* Wavy lines and stripes
Surface cleaning, 20–21
Swoosh, removing from sneakers, 43
Synthetic materials, 9, 11

T

Tape/taping, 18, 22
Team logos, 133–137
Templates, 18, 141, 143
3M red tape, 18, 22
Tie-dye effect, 17, 87–89
Tiger stripes, 37–39
Toothbrush, 99–101
Toothpick painting, 18, 25, 29–31, 55–59
Two-color gradation, 107

V

Vans sneakers, 87–89, 99–101, 156

W

Waffle shoes/Waffle Trainer, 9
Waterproofing sprays, 16, 71–73, 99–101
Wavy lines and stripes, 29–31, 127–131
White leather sneakers, 33–39, 45–53,
 113–115, 123–137, 149–151